WITHDRAWN

COLLECTIONS
OF NOTHING

COLLECTIONS OF NOTHING

WILLIAM DAVIES KING

THE UNIVERSITY OF CHICAGO PRESS

Chicago & London

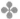

WILLIAM DAVIES KING has explored numerous odd corners of theater history in books and articles, including *Henry Irving's "Waterloo."* He is professor of theater at the University of California, Santa Barbara.

The University of Chicago Press, Chicago 60637
The University of Chicago Press, Ltd., London
© 2008 by The University of Chicago
All rights reserved. Published 2008
Printed in the United States of America

17 16 15 14 13 12 11 10 09 08 1 2 3 4 5

ISBN-13: 978-0-226-43700-2 (cloth)
ISBN-10: 0-226-43700-0 (cloth)

An earlier version of portions of this book appears in *The Oldest We've Ever Been: Seven True Stories of Midlife Transition*, edited by Maud Lavin (University of Arizona Press, 2008).

Library of Congress Cataloging-in-Publication Data

King, W. D. (W. Davies)
Collections of nothing / William Davies King.
 p. cm.
ISBN-13: 978-0-226-43700-2 (cloth : alk.paper)
ISBN-10: 0-226-43700-0 (cloth : alk. paper)
1. King, W. D. (W. Davies). 2. Collections and collecting—United States—Biography. 3. Collectors and collecting—United States. 4. Collectors and collecting—Psychological aspects. 5. Collectors and collecting—miscellanea. I. Title.
AM401.K56A3 2008
790.1'32—dc22 2007049904

⊚ The paper used in this publication meets the minimum requirements of the American National Standard for Information Sciences—Permanence of Paper for Printed Library Materials, ANSI Z39.48-1992.

For Ruthie and Eva

Another book was opened,
which is the book of life. REVELATION 20:12

❖

{ I }

NOTHING LOST

On a hot summer day in 1998, I pulled up at the house I still owned with the woman who was soon to become my ex-wife to find that she had delivered every item connected with me to the garage. My surprise was not that she had parceled out our goods, though I would rather have done the work myself, but the spectacle of what an immense and unattractive volume of me there was, much of it retained only because I collect, as a collector collects, compulsively. And then some.

There I was, forty-three, wearing shorts and an old T-shirt already heavy with sweat, in the dusty glare of desert suburbia, Ryder truck still hissing and ticking at my back as the great panel door swung open with a shriek. The door shuddered, and I shuddered too. There were the usual black plastic bags of shoes and canted piles of shirts on hangers, portable radios and razors and power tools, but also the singular multiplicity of diverse collections of nothing, a junkstore dumpster's highlights, stuff of no clear value to anyone but someone like me.

I am a collector, something a lot of people can understand. My being a collector of nothing will require explanation. I am on the small side. A neighbor told my parents I was the only child he'd ever seen who could walk upright under a table. Eventually I grew to a normal height, but I sometimes think of myself as an overgrown runt. My weight has always hovered just above normal, which is typical, I think, among people who grew up fighting for a larger portion. I have two younger brothers who could easily be cheated, though I chose not to, and an older sister who always wanted it all and could not be cheated because she was disadvantaged, disabled, disastrous, and later insane. Because of her, I tend to measure my fair and healthy share, then sneak a bit more. My eating disorder is in my collecting. I eat nothing, in excess.

I've read accounts of people who one day give away everything, purging themselves of material association. They report feeling liberated, disburdened, and alive for the first time. The moment of my divorce might have been a good moment for me to cleanse myself that way. I did not like what I saw under the bare bulb in that shadowy garage. There, mixed in with my necessaries, shone forth what had doomed me to a life of collecting—that super-superfluity of sub-substance. During twenty years of living with my wife, decades of relentless acquisition, I had found ways of weaving my collections into the lattice of our life. Now, brought out from concealment, arranged in heaps, not carelessly but also not artfully, these things looked like signs of hoarding, which is a diagnosis, not a hobby.

So I transported the cumbersummation of me into the Ryder and into my new, unmarried life, in the hope that I might locate myself somewhere in the midst of it.

MIDDLE-CLASS LIFE is itself a collection: a spouse, a house, a brace of children, a suitable car, a respectable career, cuddly pets, photos of grinning relatives, toys for all ages and hours, coffee and coffeepots, coffee cups and spoons, coffee tables and

coffee table books about coffee and about coffee tables. I had the set, and then I had another set—boxes and binders and closets full of stuff no one needs:

Fifty-three Cheez-It boxes, empty
Thirty-four old dictionaries
Three dozen rusted skeleton keys, found as a cluster in the woods
A mound of used airmail envelopes, most culled from mailroom trash
A pipe tobacco tin chock-full of smooth pebbles
My neighbor's library card from the 1960s, before he became a felon
Family snapshots of people unknown to me
Plastic cauliflower bags (many), all mimicking the sphericity
* of a cauliflower head*
Business cards of business card printers, though I had no business card
Cigar ribbons, though I did not smoke . . .

"And trifles for choice matters, worth a sponge" (Milton, *Paradise Regained*), enough odd stuff that, if you looked at each item for just two seconds, you'd be bored for a long time, if not eternity.

I LEFT BEHIND just one collection, naturally sculpted beach boulders with which I had decorated the lawn and gardens. I had gathered them on countless long drives between Claremont, on the outskirts of Los Angeles County, where I lived with my college professor wife and two daughters, and my job as a university professor in Santa Barbara. For a decade, I spent weekends at the house and the midweek at work, one hundred and thirty miles away. I would often stop at a beach on the drive home, hoping the night air might stave off drowsiness. It was there that I fell in love with these Brancusi boulders. They looked like naked bodies in the moonlight, wrapped warm and tight to each other. Soon I was rolling the larger rocks up a board into the trunk of my car. I imagine I collected a thousand or so, five or six at a time.

The next day I would place them in the yard or gardens, like a curator of antiquities home from Rome.

Ironically, this was the most beautiful of my collections and the only one constantly on display. To set these boulders off, I practiced a sort of topiary mowing, sculpting patches of alligator grass with my Murray 20 mower to accent the sea-worn contours. In the spring, lush green would arabesque salty gray. By late summer, the grass would turn sharp and sallow amid the seemingly liquid rocks, and huge wolf spiders would finish the brutal composition with no-nonsense webs. Finally, I would mow everything, hose down the stones, and start a new configuration for the next year. Many people commented on them, and perhaps they still do, though the lawn now has the conventionally trimmed look of bimonthly mow-and-blow yardmen. The stones remain, never moving, monumental. So I have left some of my heaviness behind, the heaviest of all that I was, and it looks good. When I glance inside the house now, it does not seem the same house, nor does my ex-wife seem the same person. The house looks better.

HERE ARE ALL the varieties of tuna fish for which I have labels:

Albertson's Solid White Tuna
Budgens Skipjack Tuna Chunks
Bumble Bee Chunk Light Tuna—Touch of Lemon
Bumble Bee Solid White Albacore in Water (blue label)
Bumble Bee Solid White Albacore in Water (green label)
Bumble Bee Solid White Tuna in Vegetable Oil
Bumble Bee Prime Fillet Solid White Albacore in Water
Cento Solid Pack Light Tuna
Chicken of the Sea Albacore in Water
Chicken of the Sea Chunk Light Tuna
Chicken of the Sea Chunk Light Tuna in Spring Water

Chicken of the Sea Lite Chunk Light Tuna in Spring Water
Crown Prince Natural Chunk Light No Salt Added Tongol Tuna
Dolores Chunk Light Yellowfin Tuna
Geisha Albacore Solid White Tuna in Water
Geisha Light Tuna in Water
Genova Tonno Solid Light Tuna in Olive Oil
Genova Tonno Solid Light Tuna in Olive Oil Seasoned with Salt
King of the Sea Fancy Solid Tuna in Spring Water
Kirkland Signature Solid White Albacore
Lady Lee Albacore Solid White Tuna in Water
Polar All Natural Tuna Chunk Light in Water
Polar All Natural Tuna Solid White Albacore in Water
Ralph's Private Selection Albacore Solid White Tuna Packed in Water
Ralph's Solid White Tuna in Water
Royal Reef Albacore Solid White Tuna in Water
Sea Trader Chunk Light Tuna
Sea Trader Chunk Light Tuna in Water
Skagg's Alpha Beta Chunk Light Tuna
StarKist Chunk Light Tuna in Spring Water
StarKist Chunk Light Tuna in Spring Water (with measuring tape motif)
StarKist Chunk Light Tuna in Vegetable Oil
StarKist Chunk White Albacore Tuna in Water
StarKist Charlie's Chunk White
StarKist Solid White Tuna in Pure Vegetable Oil
Trader Joe's Albacore Solid White Tuna (red label)
Trader Joe's Albacore Solid White Tuna (red label with clipper ship print)
Trader Joe's Albacore Solid White Tuna (blue label)
Trader Joe's Albacore Solid White Tuna in Olive Oil
Trader Joe's Skip Jack Tuna Packed in Water
Trader Joe's Tongol Chunk Light in Water Salt Added
Trader Joe's Wild Solid White Tuna in Water
Tuny Atun al Chipotle en Trozos Aleta Amarilla
Vons Chunk Light Tuna

I'll spare you the clams, crabmeat, mussels, oysters, sardines, snails, herring, salmon, and kipper snacks. All that, and more, remains with me—the labels, that is. The tuna has long ago been eaten, by the ones I love.

MY COLLECTING continues to be oppressive to others and myself. What I collect is not what anyone would want. When the breakup finally came in the three-year relationship that followed the end of my marriage, the woman remarked how relieved she was to have collecting out of her life. By then, I was living on top of all that stuff I had trucked north, and more, but I was at least able to write the following sentence.

I collect nothing—with a passion.

That is to say, I collect hardly anything that is collectible, not a thing anyone else would wish to collect, but at the end of the day, having myself wanted all these unwanted things, having procured them and organized them—filed, boxed, arranged, and fussed over them—I have a collection. By now, I have a big collection, since I started as a boy and now am of that age in the middle.

Perhaps you are a collector who, in contrast, collects collectibles. It has been said that virtually all children have the urge to collect, though many accumulate no more than a few pebbles, shells, or bottle caps. Some four million American adults declare that they too collect, and typically something more than pebbles. When you bought this book, did you pause to consider some other thing you might buy instead, something of which you already have more, strictly speaking, than you need? Or are you a collector of books about collecting or books about nothing? Do you have a space in your life, a closet or wall or cabinet, that is dedicated to a multiplicity of objects explainable only by the fact that in relation to each other they define a unity? If so, then you are a collector of something. I am the collector of nothing, which means I am not in the collection of collectors of something, sadly not in your company, yet I collect. Nothing.

It sounds like a metaphor, but my metaphor weighs tons. It sounds like a cry for help.

LET'S ASSUME you are a collector.

As a collector, you have nothing to fear from me. I am not the person who beat you out at the last minute in the eBay auction, nor am I the person you beat. In fact, I have never bought or sold anything through eBay, haven't even made a bid. I am also not the bargain bloodhound at the monthly swap meet, either before the table or behind. Of markets, I prefer super to flea. I've never been to Sotheby's or Christie's or a comic book fair. I am not the price-guided, nose-to-the-wind, pocket-full-of-wheat-pennies kind of collector, yet (it sounds like a riddle) I am most definitely a collector.

Of course, no collector is exactly like any other, since collectors are defined by their collections. A collector of fountain pens is not like a coin collector or a collector of Caruso 78s or palindromes or signed sneakers—or a collector of sardine can labels. Different combinations of beauty and utility and value make different collectors and their collections as distinct from each other as piano, horn, and violin, though each can play an unmistakable middle C. The music in this metaphor is *owning something in quantity for reasons beyond pure need.*

The widely shared impulse to collect comes partly from a wound we feel deep inside this richest, most materialistic of all societies, and partly from a wound that many of us feel in our personal histories. Collecting may not be the most direct means of healing those wounds, but it serves well enough. It finds order in things, virtue in preservation, knowledge in obscurity, and above all it discovers and even creates value. What *is* valuable? Rudely, consumers awaken to the modern world's sleight of hand. How easy it is to become a loser by wrongly gauging worth, bulling the bear and bearing the bull. At the same time, possessing little, going lean, can seem like double deprivation

in a world that offers so much. Watchful anxiety about the other complements doubt about our own self-worth in a competitive society. Value has become a more difficult question than ever, and collecting is a social form that responds to that question. It's a way of controlling the voracious world, the world that consumes us as we consume it. Commanding value is an assertion of identity. What is worthy? What is worth? Collectors sense the painful pragmatic and metaphysical dimensions of those questions in the modern world, by dwelling where the plane of desire/denial crosses the plane of supply/demand.

What can I get? What can you get? What can we get of each other's getting?

I BEGAN COLLECTING with a collection I did not want to keep but had to have. It was a gift, and we all love gifts, but this one I could have done without. I might have lost it then and there, and maybe I should have, but collecting filled a gap.

Marianne Danner, my mother's best friend and my own godmother, presented me with a stamp collection one day when I was eleven, in 1966. I was a worried boy in a fretful house in the Midwest. At a time when it seemed vital to own significant, timely things in order to establish an identity—a polka-dot shirt, "A Hard Rain's Gonna Fall," knowledge of Mr. Natural and Mrs. Robinson and Dr. John—I possessed no signs of the accelerating time. Instead, I had only the starter set (nylon jacket with broken zipper, green Schwinn, barlow knife, bad haircut), and so I was, in my own eyes, nothing, junior, junk.

It's not that I was poor. This is not that kind of story. In seventh grade I had read *Black Boy* and *The Jungle*, and I had learned what poverty meant, that heavy squeeze, the having of only poorness itself. I, in contrast, possessed all I needed but little I desired, and I was just then beginning to know the depths of desire. A morose character, traceable to my mother, perhaps the legacy of a long, dispirited, family tradition, had already taken hold of me. It tore at

the throat of my white, middle-class, male American birthright: optimism. I was a nonswimmer in the sea of suburban plenty. Mrs. Danner was, for my mother and me, a source of life. She could spend without fear of loss, laugh without danger of breaking down, and always say what was on her mind in an alto of pure power. Above all, she could give, and her portions were generous. This stamp collection consisted of a shoe box, two pickle jars, and an album. The album was empty. The box held fifty or so envelopes, each labeled with the name of a country or a term like U.S. Commemoratives, and each containing a few dozen stamps. The pickle jars held all the rest, hundreds of canceled stamps, in thick, scaly masses, some still stuck to the corners of envelopes, some torn or creased.

Mrs. Danner explained that a family friend had passed on the collection to her eldest son, David, and she could tell nothing would ever come of it in his fumbling hands, so she was giving it to me. I was high with my good fortune, as if I had come into a magnificent estate. Mrs. Danner knew I was suffering in those days, as I had some reason to do, and this was her fairy godmotherly wand. However, to make the collection mine, I would have to become more than my self-doubting self, not a man but a much cooler mouse.

"Finders keepers, losers weepers." I was living up to all four of these terms. The top drawer of my bureau could hardly be closed because of all the stones, charred bones, and useless hardware. Other drawers were heavy with travel brochures, bumper stickers, bookmarks, calendars, and other freebies from the county fair or the Akron-Canton airport. I found, I kept, but I also wept (unseen), glimpsing how little this fullness could do to counter my sense of emptiness and loss. But a stamp collection was something major, not a consolation prize.

In fact, the acquisition quickly proved a burden. A slim book, *The Stamp Collector's Handbook*, published in 1939, also lay within the box. This volume mostly told of the history of stamps and

methods of identifying and understanding them, but its pages were loud with DON'TS—how *not* to handle, how *not* to mount, how *not* to disrespect. At a moment in my life when I was just beginning to become fully acquainted with guilt and responsibility, I had accepted (with many thanks) a dismal fountain of those feelings. The discipline, the duty, the drudgery of being a true (betrothed?) collector sucked out much of the pleasure. Above all, I had to face the fact that the underlying theme of stamp collecting, of all collecting, really, is the knowing of value (and obtaining and preserving and enhancing value), and I knew nothing of value.

Taste and discrimination and knowledge: these are the collector's tools. The reward might be a stupendous external display, a tangible consequence of desire, plus the return that comes of other people wanting you (or wanting what you have, as if they could be you). My taste was undeveloped, my discrimination nil, and my knowledge limited to what it takes to pose as a good student in an Ohio school—not much. I was a vacant school uniform, well meaning but a nobody, plus a stamp collection.

Although they were mostly canceled, each of the stamps announced a price, and each stamp had done or could have done a certain amount of work, carrying value across a distance, transporting someone's card, letter, or package to its intended mailbox by land, sea, or air. The idea that a few odd coins can carry two or three sheets of paper from Seattle to Tallahassee is still a civil wonder. I soon learned, through the Scott Catalogue, which I found at the library, that each and every stamp retained a certain value as a collector's item, and that miraculously that value might mount far beyond the initial price, if only the stamp were rare enough, with even perforations and a neat cancellation that did not mar the image overmuch. The standards of quality were exact and high. As for me, I already knew the adolescent doubts: how even were *my* perforations, how neat *my* cancellations, how marred *my* image?

A stamp collection is a great metaphor of connection, after the fact. It is a common fantasy among stamp collectors, wanting to become those stamps, to assume a great system, to go forth in society, to encompass or Columbus the world. The stamp collector receives that whole modern myth into his album, which renews the world-dominating wonder. The essence of most collecting is to have the world in miniature, and I was determined to be a King.

I began to fill my one, slim album (*The New Pioneer Album for Postage Stamps of the World*) by matching real stamps to the photographed images printed on its pages: Bach on the 20 pfennig, Luther on the 15, Hitler on the 1, 3, 5, 6 (maroon), 6 (purple), 8, 10, 12, 20, 30, 50, and 60, peasants harvesting apples on the 10 dinar, and Lindbergh's airplane (not upside down) on the 10-cent airmail. I successfully bluffed my little brother into believing that one especially worn stamp was the first stamp ever printed. Clearly I thought these dim little scraps needed a hint of romance—or Hitler. I wanted, in what I already had, everything, every last scrap of what I lacked. The strangers who had bought those stamps and willed them to go forth had made those journeys, boxcar freight, and come to me. They required my care and handling, which meant neatly hinging them into the assigned album space.

Hard work. Ack.

I sorted the stamps in the envelopes and added new envelopes for the aliens I could not locate in *The New Pioneer Album*. When a stamp did not match one of the "Thousands of Identifying Illustrations," I would leave it in the void. These rapidly swelling and multiplying envelopes were a map of my vast ignorance: Tobago, the Marianas, the News (Guinea, Brunswick, Delhi, Caledonia, Hebrides, South Wales, Orleans, Rochelle, York). I did not know the world.

Each day I scanned the stream of mail received by my mother and father, only to find the meaning of monotony. From the rear-facing seat in our Ford Country Squire, I saw the slush re-

settle uniformly, mile after mile, on the same dull drives: school, church, grocery and department store, the predestinations. Going somewhere was always leaving the same old place behind.

I longed for more stamps, wilder journeys.

Up ahead, the adults smoked low-tars and drove the white-walls home, over and over again, to Blackburn Road. On their matchbooks I discovered the Kenmore Stamp Company of Milford, New Hampshire. For a quarter or fifty cents or a dollar at most, you could send away for twenty to fifty canceled stamps from San Marino, Togo, or the Malagasy Republic. I taped coins to shirt cardboard and awaited delivery, which usually came in a couple of weeks. Often these stamps too would fail to match those depicted in my album, but a few would match and give me a small spasm of pleasure. I had the collector's limited joy in filling, completing, mastering a universe.

A few months later, I began receiving curt letters from the people at Kenmore telling me that I owed so many dollars for stamps that had been sent. I could only imagine that my coins had been pilfered by the employees who opened the mail, because I was sure I had paid for all I had received. I pleaded innocent, but I had no proof, and the letters became stern. Finally my father wrote to the company. I do not know what he said or whether he sent the money, but the letters stopped arriving, and I stopped ordering stamps.

I was failing as a collector, which is to say failing as an adult, adulthood being something I was just beginning to face. These overdeterminations and my misery I can trace now to difficult circumstances in my family, but at the time all I knew was that I wanted to make my stamp collection into an orderly and rich place where I could go. Yet I could not wrap my head around the subdivided, angry world. Stamps jabbered in foreign tongues, refusing to colonize in the album, which was to be their home—and mine. Money was a problem, value was no solution, and I sickened just looking at the pickle jars, the clutch of smudged

envelopes, and the onionskin hinges all gummy in a mass. The collection needed work, as did I, but I had to operate alone, for reasons that will become clear. The stamp collection was my entitlement, as well as my persistent worry.

In my mother's desk, one day, I discovered a small tablet of notepaper. The paper was thick and creamy, labeled "100% Irish Linen." I still do not know what that means (paper that aped the bedsheets of Dublin gentry?), but at the time I envisioned mossy cottages where the paper might have been blocked out with Old World secrets and the Lucky Charm to uplift my life. Holding this luxurious blankness, I knew that I should join it to my collection and use its power to relieve the disorder of all those stray, troublesome stamps.

What a relief it was to create a "homeland," in the realm of my collection, for elusive principalities that had not registered in my *New Pioneer Album*: Grand Comoro Island, Sharjah and Dependencies, and myriad countries whose alphabets I could not even decipher. What's more, I would now have space for all the duplicates and oddities, like Christmas seals, a tariff stamp, a liquor tax wrapping, and a record company's miniature image of Neil Sedaka ("Choose any ten albums"). I could have thrown those things out, as a real stamp collector would, but they were comfortingly familiar, so I kept them. All this ("and wait, there's more!") I had brought forward from the disarray. The 100% Irish linen freed me to arrange the stamps as I chose—all red on one page, all green on the next. Some pages turned international— all airmail, all queens, all featuring the numeral 2 (rubles, marks, drachmas, centimes).

I labored for hours on the oatmeal-carpeted floor of my bedroom, door closed, repelling all intrusions by my brothers, including the one who shared the bedroom with me. I was hot with the fever of creativity and a little delirious. Against all reason, I hoped no one would ever, ever notice that I was Scotch-taping these stamps to the pages, directly contrary to the commands of

The Stamp Collector's Handbook, because I just knew no one would ever dream of removing them, and it was god-awful tedious to apply those stupid hinges! and fuck it! and piss on the value! I had found and used my anger. The collection began to stand for my deep wish to be done with the problem of what I could not handle. Somehow, I already knew Wordsworth (whose name I had never heard):

> The world is too much with us; late and soon,
> Getting and spending, we lay waste our powers;
> Little we see in Nature that is ours;
> We have given our hearts away, a sordid boon!

I wanted the world's worth, clean and potent. Stamp collecting was my Prelude. Collecting against collecting was my effort to grow up all at once, while keeping my heart, my sordid boon.

Word got around the house that I was working on something "weird," and when dinnertime came and I put down the work, my family looked at me with curiosity. The question came from my father, "What the devil have you been doing?" What the devil *had* I been doing? Suddenly, tight in the throat, I felt unprepared to answer. In fact, I had committed an atrocity. How could I justify or even excuse this treatment of Mrs. Danner's gift, not to mention the Irish linen? I tried to divert their questions until I could know better what to think, but they pressed on. My brother Andy sensed, with a fraternal instinct for cruel opportunity, that I had at last ridiculously and terminally overreached myself and would soon sink, like that first time water-skiing when, coming to the end of my awkward, half-assed ride, I had smartly saluted the adults on the dock, as if I were Commodore Cool in an orange life jacket, before descending into the lake.

Even now I collapse at that memory, and I was cringing there at the dinner table. What the devil had I been doing? In the end, I had to bring my pages out to show.

MY MOTHER: Where did you get this paper?

MY YOUNGER BROTHER: Why are they crooked?

MY FATHER: You've got German stamps on the same page as French?

MY YOUNGEST BROTHER: Let me see the germs.

MY MOTHER: I'm not so sure about that tape.

MY YOUNGER BROTHER: Why didn't you put the stamps in that book where they're supposed to go?

MY FATHER: It's spelled H-U-N-G-A-R-Y, not H-U-N-G-R-Y.

MY YOUNGEST BROTHER: I want some hungry stamps too.

MY MOTHER: (*Sighs.*)

MY YOUNGER BROTHER: (*laughing*): You wrecked the stamps.

MY FATHER: (*Chuckles.*)

MY YOUNGEST BROTHER: I wanna hold it.

MY YOUNGER BROTHER: No, me!

To this day, I rarely use a pencil because of how I saw it looked that day, the D-for-poor quality of my thick titles, also the clumsy efforts at achieving balance and symmetry. Irish linen, Mrs. Danner, Togo, and me—loss upon loss, a crying shame.

I think I later just threw the whole goddamned mess away. In any case, that day was the last I brought out or even touched my stamp collection for many years.

WHEN I DID pull it out, a dozen years later, it was with a different intent, one I have been trying to explain ever since, an impulse to own something that is nothing, a collection of nothing. For the last twenty-five years I have been placing in the vacant spaces of *The New Pioneer Album* those little rectangles you find in the upper right-hand corner of certain envelopes, stamp outlines usually containing instructions to Place (or Put or Affix) Stamp (or Postage or Postage Stamp) Here. Some specify "1st Class Postage" or "U.S. Postage" or "Sufficient Postage" or exactly how much postage. Some say "Please," some "Thank You," and some season their thanks with a dash of guilt: "Your Stamp

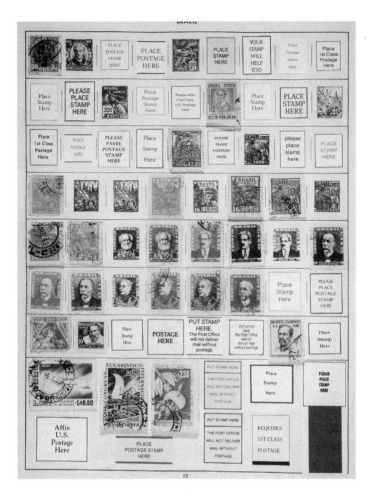

Helps Fight MS," "Your Gift to KCLU Starts Here!," "No Stamp Needed, but If You Use One More of Our Funds Go to Help People Who Are Needlessly Blind." Some are prepared for world travel: "Apposer un Timbre Ici," "Colocar la Estampilla Aquí." And recently some plead to remain blank: "Wait! Save Your Stamp! cox.com/easypay." Many add some variation on "The Post Office Will Not Deliver Mail without Postage" or, less wordily, "Postage Required for Delivery." Others are more taciturn, settling for

"Stamp" or "Postage" or simply an empty rectangle, trusting that the point is obvious. Each of these messages can be found in a variety of fonts and colors and sizes. I carefully snip these would-be stamps from the envelopes and mount them in the album. I handle them, and I glue them, and I do not sort or categorize them. Forty-six pages of this album are now respectfully filled with hundreds of examples of these great stamps of expectation.

The completion of the world of the collector is the summation of all that is still wanted, the totality of expectation—Place It Here. Many collected items begin as souvenirs, but this collection points not to the past but to the anticipation of that moment when there will be no more blank spaces in the album, no more need, when the world will be filled with the nothing that is the collection. As an answer to a pathetic need and an anguished sense of loss, this collection embodies the essence of what it is, for many, to collect. It also lacks exactly what justifies collecting for most people, which is substance (almost entirely) and value (entirely). A "Place Stamp Here" is nothing more than an expression of the need for something valuable. So this collection begins deep in the hole, and each year, as postage rates creep up, it becomes more preciously valueless.

Is Memory most of miseries miserable,
Or the one flower of ease in bitterest hell?

DANTE GABRIEL ROSSETTI, "Memory"

There was an ash pit out back. In a time before I can remember, the neighbors fed their trash to an incinerator. It was still there, starving, toppled over and rusting, grass growing through its sides, but no grass grew on the ash, which had stiffened into fine gray clay. I learned the word "archæology" there. Eden lay under fifty layers of ruin.

The treasures were simple—bottle cap, bobby pin, nib of a fountain pen, blade of blackened glass, flint wheel from a Zippo lighter, ball-peen hammer head, many bones (none human, some blackened, others bleached)—but with them I constructed a whole world. A world whole. It took six days, or more, with breaks for peanut butter and jelly.

My boyhood was not in ruins exactly, but certain things had broken, others were burning, and much had gotten buried. I needed to dig deep in that ash pit, and I still do. I look for something warm.

I GREW UP in Canton, Ohio, an hour south of Cleveland. It was, in every sense, Stark County, Plain Township, in a suburban neighborhood where the streets are all named after American generals. President William McKinley lived in this city, but there is little trace of that legacy since the city decided many years ago to dismantle his house, with its famous front porch, and cut the lumber into tiny souvenir gavels. The city is known for football, which I never played beyond the backyard, and heavy industry, which at the time of my childhood seemed on the verge of collapsing in a heap of rust, and finally it did.

I immersed myself in the Golden Age of Television, with its ceaseless, idle enticements. Top forty on the radio, Mattel and Tonka in the toy chest, the funnies pulled first from the Sunday *Plain Dealer*. From where I slept, on the bottom bunk, I could see the globe on my bureau, with its skullcap ring telling how, when it's bedtime here, it's breakfast somewhere else. My world was small and hollow and made of glossy cardboard, through which I pushed pins to mark the very few places I had ever been, never on a mountain, never by the sea. The Encyclopædia Britannica filled in a few details. I read *Mad* for irony, Signets for sentiment, but mostly my life was like the sound of a distant lawnmower, a dull murmur going round and round. When it wasn't raining, I rode my bike through the similar streets and alleys and the

muddy paths of orchards soon to be developed. On these journeys I might come across other sites of human deposit, where someone had dumped a shopping cart or car, dirty books and condom wrappers, rusty tools, a pile of moldy clothing out of which a belt buckle gleamed, always a possible treasure. I studied archæology there too, in the wasteland, my New World.

What's not worth picking up? What could I get for nothing, that word I knew so well? These were questions worth study. I cannot say I ever felt satisfaction in my scavenging, but I was distracted from my want, and perhaps that's all that satisfaction ever is.

What did I want? That is hard to say. Closure of the wound? Engagement? Transcendence? God? In things, I had ample metaphors, but for what?

MY MOTHER had been a collector of stamps as a kid. She was an only child, often lonely, and always seeking ways to occupy her time, searching for a different, better world to enter. She specialized in U.S. mint blocks, groups of two or more uncanceled stamps, usually four in a neat rectangle. She kept her stamps properly mounted in an album specially designed for the purpose, a proud possession.

One Sunday morning she came down for breakfast and found my brother and me using our crayons to decorate or desecrate her album. I was probably seven, Andy about five. The sudden fury, burst of fear, quick acceleration of guilt struck through me head to foot. As she recalls it, we were tearing her stamps to pieces. So wounding was the assault, she claims never to have looked again into the ruined album. We had burned the flag, its presidents and stately images, and the motherland itself.

We had stumbled upon a private place or part in her life, the remnant of an early effort to cope with loss and isolation. She had a mother who hovered not near, a father who could not make up the difference, and a well-kept stamp album that took

her places and remained at home. In that intimate space, we had found surprising colors and rich imagery, and we wanted to join ourselves to her world by means of our coloring. Yes, there was some hostility in this act, some attack on her heart, perhaps because we felt we had inadequate access to such warmth as it contained. Lately I have inspected the damage to the album, and it does not seem that bad. There are several telltale crayon marks, but nothing is torn. Maybe the damage was contained and repressed, like Love Canal. That would be the impulse in our family. Collecting itself is about containment, and we had many miseries to contain.

MY SISTER, eight years older, had been born with cerebral palsy and some mental insufficiencies. She was somehow at once "slow" and "normal" and "extraordinary." She was very demanding, highly excitable, and often angry at the world, at our mother, and at us, her brothers. Andy and Peter are two and four years younger than I am. In between my sister's birth in 1947 and mine in 1955, my mother miscarried twice. Earlier she had given birth to a child who died the next day. One doctor advised her to stop trying for another child (altogether she was pregnant ten times in about twenty years), but she and my father would persist, and eight years later I was the product of their determination. Cynthia McKown King had had ample time to prepare for sibling rivalry before I came along.

Cindy (also known as Cinder or Luge) was hard on my mother, cruelly accusing, raging with all her breath, when she wasn't whining or wailing. My mother understandably withdrew: headaches, naps, books and magazines, the telephone, the bridge group, cocktail hour, the kitchen. Cindy shrieked at us, domineered, and jealously held her position as alpha child. Surely she felt threatened by three healthy and able boys shooting up all around her. She hoarded my father's attention, often required his arm, his back, his words, and every bit of his spare

time. He was a doctor, and she his (impatient) patient. My brothers and I ministered to our own needs, with the help of the family housekeeper, Nancy Hughes, because we were "good." We had the "freedom" to be good, which was a duty to pretend that being good meant freedom, that such suffering as we felt could be (patiently) borne. Cindy had the "right" to be horrible, to cry out, "My sufferings come first." Nancy, our guide and mediator, cared for us and distracted us from our own isolation in the family with the dull routine of soda pop, gossip, sweeping the garage, and soap operas. Her little girl had died before we knew her, and so we became her surrogates, and she ours. Nancy was the only one who could stand up to Cindy and never back down. To this day I reach for the power I saw in Nancy when I find myself facing someone's fury. She would not take it to heart, would not waver, and we rarely saw the rough edge of her ability to go on.

Nancy's resilience with Cindy had a nurse's authority. It was based on a reading that Cindy was in a category of her own, requiring some Christian charity along with a strong hand. On us Nancy impressed the lesson that we must never resent such a one as Cindy. I knew in my head all the wicked puns on her name, which all began with "sin." In a public place, we learned to be protective of Cindy, shielding her from the stares of others, since she always talked too loud, moved with a clatter, giggled inappropriately, or pitched a fit. Cindy was mile-a-minute and so-slow, rebellious teen and fascist pseudomom, teeny-bop hipster and egoistic shit-kicker. There was no peace in her presence. It was hard to feel this life was normal or even real, and we grieved that fact daily.

UNREALITY. Cindy would tell you the telephone was going to ring before it rang. At least, that was the story we told about her, and my father swears it is true. The point is we believed she had supernatural powers, and our evidence was not such a mundane miracle as telephonaudience. What was truly remarkable in

our buttoned-up family was that she would listen *and* hear, see *and* see through. She could pick up the repressed thoughts and feelings of others and, without apology, report what she detected. You could not keep a secret from her, but this did not stop us all from trying. We became experts at performing unreality. We learned containment, and I, in particular, found ways of burying my anger at her deep in my soul, beyond my own reach, for example, in objects. I knew how unfair it was to blame her for the catastrophe known as "my life," and so I fled behind closed doors.

One night, when Archy, a friend of mine, a hulking playmate with hair mowed short, was staying for a sleepover, and Cindy was fuming because she could not be trusted to babysit, she hit me hard (with words or fists or crutches I cannot remember), and I closed myself in the upstairs bathroom and realized at last what a lake of tears I had inside me, what thermonuclear anger I hid even deeper. I was staring terrified into the huge "cannot hide" mirror at my wet and gushing and twisted face—ugly as Hell, I thought, as Hell—while Archy pounded on the door and begged me to let him in. I could have let him in, but instead I chose to keep the door closed on myself and on that quantity of hurt and anger, then and thereafter. The ugliness of my wretchedness made me sick.

UNREALITY. It was strange that I should feel so brimful of anger since I was the lucky, hale and hearty one, strange that I should feel fit and male in a house defined by Cindy's disability, strange that I should feel that Nancy, not my mother, was the one to count on for the daily contact and petty liberties of childhood, strange that I should feel guilty for living when I was a dream come true for my parents. It was strange that this clatter of metal—braces, crutches, and wheelchair—should so dominate my idea of what it is to be human.

It was not strange that I withdrew from life, despite the fact

that I had advantages, access, and ability. My family was loving, though stretched too thin, ordinary, though scarring heavily around its one obvious lesion, the constant crisis of Cindy, not to mention several others that were not so obvious. Why did I fear my father? Why did I feel so inhibited in my speech? Why were our bedtimes so early that we had either to trick ourselves into sleep or to find covert ways of staying up? Why did I develop the habit of learning only what I taught myself? Why did my father constantly embarrass us with dirty jokes? Why was my mother often on the verge of tears but only willing to cry behind closed doors? Why did I feel so alone and so oppressed by others, so constantly homesick and so sick of home? My collecting had already invisibly begun during those childhood years. I had a sort of album of all the emotions I could not handle: Place Stamp Here. Some fatefully offered, spontaneous thing, in sufficient richness—a distant aftereffect of Providence—might match my want, and every night at dusk I drummed on the mattress to hear the heartbeat of my expected self. Then, I slept.

WHEN CINDY WAS EIGHTEEN and I eleven, along came some hope for her. A surgeon shifted tendons in her legs, giving her the chance to walk unassisted for the first time in her life. She was in the hospital for several weeks, then home and working like a demon on her physical therapy. She had nearly graduated from high school and was determined to make something "normal" of her life. My father was trying to think of a business in which he could set her up. She hated most of the handicapped kids with whom she associated, despised the retarded kids in her special ed classes. She longed to blend in and had no patience with anyone who classed her as "special" or sparked her disability dynamite. My brothers and I shared her soaring faith that an end might come to the nightmare of her life. Cindy would walk. That was the vision. We helped clear the path in front of her, hoping her release might release us.

23

A handsome, young black man named Dave was Cindy's physical therapist. She worked with him nearly every day for an hour, and we heard constantly about what Dave had advised or forbidden. At home, we carried out his recommendations, massaging Cindy's hairy legs and walking her back and forth along a hallway that had a railing for her to grab if necessary. At her best, she could rise from a chair by herself and stagger across the room. Progress beyond that would come slowly, if at all. In short, there was no miracle. When she was frustrated and angry at one of us (often), she could move in her own way with terrifying speed, and the effect was even worse when she had her metal crutches. She became a madwoman, and I, her closest rival, eldest brother, self-locomotive in the worst way, an excellent student in sixth grade, left halfback on the school soccer team, and just starting to do the things teenagers do, like going to dances and hanging out with girls whose parents were not home, frequently felt her fury. Those crutches were like weapons. Those crutches were weapons.

THEN, ONE NIGHT, I woke up to my parents passing back and forth through our intervening bedroom, and to Cindy screaming at a new pitch of agony. Andy was awake too, but we were much too scared to say a thing, to move, or even to breathe. A thunder of adult footsteps in the dark. Terse conversations in a panicky whisper. A struggle. Gasps and cries. Lights burning my wet eyes. Doors shutting with a click, a very bad click. My mother and then my father tried to calm us by saying Cindy was having a bad dream, but I could tell from their tone and from the fact that Cindy was still raving and whirling in the air like a strange propeller that something more serious was happening. I do not remember much of what she said, or screamed, as it was filled with crazy strings of speech, but frequently, loudly, unmistakably, I heard her shout, "I hate Dave." That name became the target of her fury—Dave, her nemesis and betrayer.

MY NAME IS THE SAME as my father's, William Davies King, and he is called Bill, while I have always been Dave. Unreality.

Of course, I knew that Cindy's belief in the power of Dave, her therapist, had collapsed once she grasped that the miracle of striding across a room—or a continent—with perfect grace, had not happened, would not ever. I think she had a teenager's love for him. He was her knight and savior, her healthy other half. Through his power the evil spirits would be drawn out, and she would throw down her crutches and walk. She would walk. She should walk. She tried so hard to walk. Walking was everything. But walking was a step beyond where she could go, and then she felt betrayed, shut out of the garden of hope. In fact, she was out of her mind. With the onset of schizophrenic breakdown, she plunged into hallucination, and the real matter of her life became tossed in that surreal sea. One Dave could easily transform into another, and I enlisted in that insane metamorphosis in the role of betrayer. I knew myself as the one who, even as a loving brother, had wished her to have less attention in the house, who wished she would take her tragedy and get the hell out of my life, the one who wanted her to fail. I would do the Irish jig, the do-si-do (spin, kick, sweep, punch), and the up-the-riverdance on her lame creek. And my wish had come horribly true.

CINDY WOULD HAVE PLENTY OF REASON to hate me, and I myself, but I contrived that my parents would have few. I would continue to do well in school. I would rebel little. I would not get in trouble. I would be no problem. I got a lot of favor out of my model behavior, my compliance and self-restraint, but each stifled impulse became an object for me to carry around, to collect, and my album quickly bulged. My father's joking slogan for his medical practice was, "If it's good eyesight you're seeking, see King." This King, though, we could not see, but I, I blinked, and in the darkness I saw myself.

Cindy was taken to the local hospital and from there to the

loony bin. I know the place was not called that, but when my brothers and I were finally brought to visit her, at Applecreek, perhaps a month after the breakdown, the term matched what we saw: boys banging their heads against the wall or sitting inert, women raving. Here, in the middle of our already freaky lives, we sat beside the unreality we had to know and love as our sister.

As a family, minus Cindy, we consulted a soft-spoken Swedish psychiatrist (who some years later blew his head off). Across a big desk, he provided us with some explanation of what had happened to Cindy, though I have no idea what counsel he gave, if any, while I stared at his nameplate, at the letter Ø, and thought of how I had heard he ate raw eggs before dinner, a Swedish custom. That was the only professional help we received. No wonder that seeing Cindy in a hospital bed, obviously doped and stuporous, was impossible to take.

At one of our three or four visits, when she was more awake, she offered her own story of what had happened to her—a dream? an allegory? a challenge to me? She said she had been tied in a chair in the middle of a large room and that the chair had risen up off the ground to the ceiling's height and had turned around three times. When the chair came down she was . . . changed. I see this scene in every sterilized, gray detail. The room is very large, perhaps an airplane hangar. The only light angles in under a large garage door, which is open by a foot or so. So bright is the glare off the polished concrete floor that I can see every detail of the plain wooden armchair in the exact center of the room, where Cindy is tied. A steel brace holds her head in place. Her eyes are rolled up, staring up at something I cannot see, perhaps an Annunciation. I hear a hissing noise and feel the room vibrate, then the chair rises, perfectly level, until it is hovering just below the dark and dusty rafters. Only after the chair has come to this height does it begin its slow, steady turns, one, two, three, wobbling slightly with each rotation. Cindy remains mo-

tionless, her eyes still upturned. Then, again the hissing noise, and the chair descends. I can see it faintly glow as it reaches the floor. Cindy is glowing too.

THAT SAME YEAR the art teacher at my school announced that he would direct a production of *The Unicorn, the Gorgon, and the Manticore* by Gian Carlo Menotti. He proposed to audition the seventh and eighth graders by having us all parade in a large circle, looking as much like counts and countesses as we could. Somehow I knew that all those noble roles would go to the eighth graders, and my only hope of appearing at all would be to do something unusual. So I decided I would be a beggar, a low and ignorant type, and what's more, a lame beggar. I hunched my back, twisted my hips, and dragged my leg behind me, wearing an insane expression on my face. The director had to ask me what I was doing, but once he understood my intention he loved it, and I got cast. Only many years later did I realize that I had been impersonating Cindy.

COLLECTING is a way of linking past, present, and future. Objects from the past get collected in the present to preserve them for the future. Collecting processes presence, meanwhile articulating the mysteries of desire. What people wanted and did not want drives what collectors want and do not want in anticipation of what future collectors will want or will not want. The mathematical formula connecting these equations of desire is mysterious and difficult, but all collectors engage in such calculations. Usable things sometimes become collectible, but collectible things rarely become usable. Instead, there is a special field in which the object runs free of use value, like a retired racehorse, occasionally photographed, often bred. One chess set, one Lionel train, one Rachmaninoff performance, one picture of Niagara Falls, becomes a dozen or a hundred or a thousand, and in that crowd, a few stand out as Derby winners. Collecting

integrates the striving for a winner with affection for the losers, so that, in the end, both win.

Why? The answer lies in the basic quest for fulfillment. "Fulfill," a transitive verb of Old English heritage, originally meant to fill to the full. You could fulfill a material container, and later any void at all, however abstract, if only need or desire attended, and eventually the word came to stand for the filling full of need or desire itself. The longing-for makes possible the fulfillment, which is the aim of all collectors, a miraculous effect always pursued—bringing the magical potency of the desired object within one's grasp.

Every collector is always waiting. Attain fulfillment and the collection ends. But fulfillment is never attained because the effect of acquisition constantly drains away in ownership, and so the hunt goes on. Always there is one more possibly graspable object of still higher longing. A kiss answers a desire, but it also stirs a desire, for another and another, until the mythical ultimate kiss. For most, the kiss is selective. For hoarders, it is everything. For me, the kiss is of nothing.

For all of us, the pursuit has its pleasures, and some sensation of fulfillment comes in the rhythm of acquisition. Seeing the album fill up—or the shelf, cabinet, or closet—feels good. I think it is akin to the "belly full," and we all want that—the long day of skiing followed by hundred-year-old brandy and Belgian chocolate, dinner at Silver Palate or Au Pied du Cochon, Puccini with Domingo, Alfred Brendel at Disney Hall, sunset on Mount Kilimanjaro, days of Bali Hai. (I have done *none* of those things, having collected nothing instead.) Wilhelm Stekel, an early Freudian disciple/dissenter, called collecting one of the "disguises of love" in his 1922 book of the same title, emphasizing its erotic aspect: "No doubt the stamp-collector travels round the globe by means of his stamps; he lives in the history of the stamp; he dethrones kings and celebrates memorable historic events through the possession of a particular stamp. But, when

all is said and done, it is but a harem that every collector establishes for himself. . . . All collectors . . . draw their sustenance from spirits; they feed their love-hunger with shadowy phantoms. For this reason the collector never attains peace; he never ceases to collect."

Many collectors, virtually all, seek their pleasure in the marketplace. Money must go for fulfillment to come. That might seem a debasement of the activity, and noncollectors frequently scoff at what seems, on the one hand, compulsive or self-indulgent, and on the other, mere peddling. Some collectors respond by laughing all the way to the bank. Many feast on appreciation and talk of nothing but how this or that piece has gone up five or ten or twenty times in value, but few collectors actually sell (sellers are merchants, a different breed), so this talk reflects a self-justifying fantasy. Most collectors know that money becomes an unreality when you regard a beloved object. There can be no waste. Whatever you pay, whether it is x or $2x$ or x^2, it never seems too much because desire makes up the difference

There are collectors who do not amass, in a physical sense, such as those who fill their heads with shaggy dog jokes, birdwatchers who hope to check off yet another species on their life list, others who collect one item only to discard another, and many who think small or even miniature (figurines, thimbles, coins, spoons, wee books). But collectors all occupy a conceptual space that is the enlarged but displaced sense of self. Every day in every way our collections will get better and better, even if the world does suck rocks.

LIFE WITHOUT CINDY was enormously different. Better. For the first time, we even went on a family vacation, all the way to Detroit, flying from Canton to Cleveland, from Cleveland to Detroit, in planes that buzzed so loud our ears sang for an hour after landing, and there we visited the Henry Ford Museum. I loved the beautiful, polished forms of old machines and cars

and tools displayed there. For the first time in my life I was seeing a great collection. They even had Thomas Alva Edison's last breath, captured in a jar! I discovered my affinity for museums, also warehouses, safe deposit vaults, basements, and attics. Our local newspaper was the *Canton Repository*. Others laughed at the name, but I had only good associations with that word. Collectors reposit.

It was also about then that I first visited the farm of Marshall Belden, cousin of my Uncle Louis. Marsh came from the family that made big money in Belden Brick, but he himself had earned a fortune drilling for oil. He didn't own the wells, he owned the expensive drills. He was the first great collector I ever met. He collected guns and Civil War uniforms and Canton memorabilia and myriad other things, but above all he collected old cars and everything to do with automobile culture—gas pumps, signs, repair manuals, road maps, bud vases for the dashboard, tire gauges, windshield wiper blades, dusters and goggles, AAA guides, and motel memorabilia. This collection eventually became the Canton Classic Car Museum. He had barns and stables filled with costly things, the grand stuff one could own without apology, Duesenbergs and Packards and Cadillacs, and the walls of his house were covered, floor to ceiling, with wonderful old pictures and documents and auto oddities in handsome frames. As a man, he was "a character," rarely seen without a glass of Old Taylor in hand, alternately shy and brazen, always ready to chuckle at his own oddity but ever intent on acquisition.

Some years later, my aunt and uncle moved into a renovated outbuilding on his farm, outside Canton, and I looked forward to visiting them because I would be in the neighborhood of that collection—a rich, though unglamorous, world. One barn contained the disassembled pieces of the shack that Marsh's father, a pathological recluse named Mose, had built on a huge piece of empty land outside town. Then one day he was shooting up some food, when up through the ground came the fastest grow-

ing mall in America. I did not want that shack, as Marsh did, who was trying to recover his childhood, but I wanted the collective unconscious, the collecting soul. The rest of the world, on the other hand, just wanted that land and paid handsomely. With the discovery of oil in Ohio, Mose led the Beldens out of Egypt, and Belden Village was the promised land. Marsh himself was rarely seen, but I heard stories of his *har-har-har* attitude toward buying anything and everything impractical (mechanical toys, guns of all sorts, a fire engine and hearse, vending machines, and things to do with William McKinley or his great aunt Ida), and already I knew I wanted such stories to be told about me.

But where was my mother lode, my Belden Brick, my Ohio tea, my shopping Valhalla? I mowed small lawns for small change, and while I never lacked a thing I might need, I certainly had nothing from which to build a great collection. Middle-class collectors have only a pittance with which to make a world, and so their collections tend to be narrow and silly: Coca-Cola ads (pre-1945) or ballpoint pens (retractable only) or telephone pole insulators (blue). I had no lust for Depression glass, depressing Lladrós, Olivetti calendars, postcards of prestatehood Hawai'i, Bakelite radios, Union Pacific railroad guidebooks, or anything so defined and picayune. I desired Hearst Castle, which is to say gross totality, however vulgar, but only on my budget, which was zilch.

Despite my meager funds, I started bicycling each Saturday morning to the estate auctions I saw advertised in the paper, where I would take note of wonderful objects to covet, things that might answer my need to be an owner. However, the few crumpled dollars I had stuffed in my jeans kept my attention tied to the boxes of bric-a-brac and potpourri and nearflung gewgaws, which were always assigned to the very end of the auction, when the high-end collectors had already roped their prizes to the roof of the station wagon and driven off. I thrilled to crates of chilly hardware—coffee tins of rusty nails and mismatched bolts and nuts, odd attachments, gimcrack, rickrack,

and adscititious crap—because at least then my dollar or two would bring me something hefty, clumped, and durable, in good quantity, penny per pound. Sometimes my fifty-cent bid would be enough to claim it all, and I'd sweat to get it home by bike, understanding at last what I really meant by "adscititious crap."

Much of this plenty was useless, of course, nothing to be done with it, but it seemed I could always come up with a find, some exceptional, useless form in steel. I especially adored round things: wheels, gears, spigots, bearings, spindles, dials, nuts, spools, links, loops, knobs, anything with curvature. Nourishment came from these little breasts, bliss from these stubborn beings. I took the time to shine them to a warm glow, using the oil from my adolescently afflicted face.

Naturally, there could be no complete collection of round things in metal, so what I was striving for, instead, was a set of fine examples, triggers of association for all that roundness, smoothness, and glimmer might bring to me, which was a lot: completion, marriage, wholeness, endurance, beauty, sustenance, sanity.

WERNER MUENSTERBERGER, in *Collecting: An Unruly Passion*, defines collecting as "the selecting, gathering, and keeping of objects of subjective value." He emphasizes the subjective aspect of the value because collecting somehow takes a person beyond rational economy to a realm where intuition and sentiment rule. If the tendency of human thinking over the last three millennia has been to deanimate the objective world—to see the divine not in the wind or sun or sea or trees but in abstractions—then the collector is a throwback. A collected object seems to speak, to answer, and to inspire, as an oracle. The collectible commands obedience, even reverence. It also requires care and proper handling, like a pet or plant or child. Collectibles have history; in a way, they are the substance of history. They entangle you in a network of relations, like family members. They fight for individual identity and self-definition, like the human subject in

modern society. Collectibles have soul, or else they are very good actors and we their dupes. Muensterberger writes:

> Objects in the collector's experience, real or imagined, allow for a magical escape into a remote and private world. This is perhaps the most intriguing aspect in any collector's scenario. But it is not enough to escape to this world only once, or even from time to time. Since it represents an experience of triumph in defense against anxiety and the fear of loss, the return must be effected over and over again.

Collecting is "religious" in the etymological sense of gathering or binding together again. Precious objects coalesce, and the divine (or the diabolical) is there in the collectible. Collecting is a form of sorcery (or prayer). The metaphysics of collecting were clear to me at thirteen.

The other sort of box I could afford was the box of odd books, and there too I could sometimes find roundness, smoothness, and polish among the remains of the day's sale. One day I thought I had found my destiny. I knew about Dante through the illustrations of *The Inferno* done by Gustave Doré (somewhere I had seen this amazing book in its Dover reprint). At an auction I bought, in a state of feverish excitement, a handsome two-volume edition of the poems of Dante Gabriel Rossetti, one of the pre-Raphaelite poets, a decadent Victorian, thinking I had acquired *Inferno, Purgatorio, Paradiso*, and probably other nifty poems. I had not even glanced at the contents. The books were in a box among a lot of dull paperbacks, and I prayed that no one else had seen them.

No one else had cared to see them.

Unexpectedly, when I returned home with this prize, I found a friend of my parents, Ellie Hoover, who had married unwisely into the Hoover sweeper money and who was a great collector in her own right. She had amassed a collection of early American

antiques that is surely now worth millions, having once been worth thousands, having never been worth nothing. I recall boasting to her and my mother, as if I were some prodigy, that I would now concentrate my talents on becoming a book collector. I brought out my edition of the famous poems by Dante, as if I had a fourteenth-century incunabular copy, only to realize, just minutes later, that the poet whose books I had bought wrote nothing finer than "The Blessed Damozel," which I had not the patience to read, then or now.

I still have the books, though. They are part of my collection of shame-filled souvenirs, and at last I read Rosetti's "Memory," there to find myself, midway on life's journey, in bitterest hell.

{ II }

NOTHING GAINED

At thirteen, I had to collect. Collecting collected me. It was 1968, and the Vietnam war was rattling, protests loud and long, hair growing everywhere, and legal and illegal, moral and immoral, smoke in the air. My innocence was already casting an eye on Canada.

Those furry role models, my parents' friends' sons, were listening to Dylan and Donovan, reading *Playboy* and Brautigan and Hesse, and developing that glassy stare. I was finding it daily tough to become a teenager in this confusing world, but I was getting somewhere at last, had my first slippery kiss, snuck out of the house at night in dark turtleneck and jeans with busted knees, gazed at the moon through a television aerial, and heaved my first adult sigh. My parents, though, lifted their Republican trunks in alarm at the stories they had heard about Glenwood High, and so we went on a tour of New England boarding schools: Governor Dummer, Tabor, Hotchkiss, Deerfield. My father crafted my application essay, which was about my sister,

after rejecting mine, which evidently did not cut his mustard. He evidently knew better than I did why I merited attention, for "my" tragedy, Cindy. I had the test scores, they had the money, and so I was admitted to Phillips Academy Andover.

I remember feeling proud to have been accepted. I enjoyed knowing that I could fulfill my parents' wish for me. I remember loathing the idea of leaving home, especially now that it was so much quieter there, and I was the oldest, and my sleek girlfriend, who called me Puppynose, had opened her mouth so I could know her orthodontia with my tongue. My classmates threw a party shortly before I was to go away and gave me funny, mocking gifts that made me think they liked me and perhaps also pitied me, or perhaps they had their own longings to be institutionalized. One actually gave me a box of nothing. This was a novelty gift, a cigar box whose label boldly declared that nothing—"100% Pure Nothing"—would be found within, a claim that proved 100 percent accurate. The going-away party fell to pieces when A. told us there had been a fight somewhere, and B. had broken the arm of C. for no good reason. We all scattered through the neighborhood in angry pursuit. I recall eventually walking home alone, Z., indistinct, nauseated at the prospect of a thirteen-hour drive to the "distinguished" school I had seen only once.

Somehow I was assigned a "psycho single" in a small cottage dormitory, a bare cell with one narrow bed, desk, chair, radiator, window. Ultimately I came to see the benefits of a private space and a relatively quiet dorm, but at first I felt singled out for my inadequacy. The other boys in the house were friendly enough, but they all came from wealthy stock and had traveled the world. The first one I met looked and acted as old as my father. He was my age, but I goofed and called him "Sir." They all knew about sailing, skiing, restaurants measured in forks, and high fidelity. They owned hookahs, lilac granny glasses, and signed double albums of the bands John Lennon had been reported to say he liked, while I lacked sense and sinsemilla. I had no tales of Swit-

zerland or the Village or Belize, no deep knowledge of sports or politics or science, no knack for drugs or sex, not much to say for myself at all. I did not even have a brother to bully.

To this life, I had brought a few of my favorite metal objects, and I continued my practice of polishing them, but otherwise I had nothing in my suitcase beyond the items called for in the academy's checklist: ten shirts, three sport coats, five pairs of chinos, three towels, one alarm clock, and so on. My world was empty. This was why I had to have a collection.

MOST CHILDREN COLLECT THINGS. Theory says that such assembled objects are extensions of the "transitional object," which is itself a fill-in for a lost connection to the mother. I do not recall having a security blanket or a special teddy bear, but I surely must have found objects to give me infantile comfort. Before memory kicks in, we need mnemonic devices of that sort to remind us that parental love is continuous, even if it is not immediately at hand. As the child enters adolescence, the collected objects get replaced by social connections, especially romantic attachments, which are far less steady and sometimes undetectable. We learn nostalgia, the tug of past objects, very early. Such connections as I had made in Canton were lost when I went away to Andover, and the social connections still to be formed there seemed more difficult and unlikely, while romantic connection in an all-boys school was not my cup of tea. For this reason, I held onto treasured objects longer than most.

A collector can be an ascetic, someone who cultivates only one narrow category of collectible and possesses little else. A collector can be an omnivore, always looking for ways to extend one category to all others. A collector can start small and, by concentrating his peculiar effort, wind up with an empire, or start big and wind up with a gem. A collector can do almost anything, so long as it tells a heroic story. Somehow I had to become a collector/hero, so that a story might be told of me.

Collecting is a constant reassertion of the power to own, an exercise in controlling otherness, and finally a kind of monument building to insure survival after death. For this reason, you can often read the collector in his or her collection, if not in the objects themselves, then in the business of acquiring, maintaining, and displaying them. To collect is to write a life.

I went out into the world, hour after hour, to scout pieces of metal I could polish and arrange on my bureau, on my window seat and sill, on the floor and bed. Sure enough, when I looked, pieces of metal were there for the taking, in basements, attics, closets, and trash. Remove the rust and grease from almost any twisted piece of steel, and there will be a touching story of form deformed. My room gradually filled up. I walked miles on the local roads and through the woods. I descended into the cellars of academy halls and came back with priceless showpieces of disused utility. With a rag I would polish them, while doing my homework or listening to the radio, during class, chapel, and indoctrination (they advised us not to smoke, to buy low and sell high, to bow to the powerful but not to ourselves). Even an old gas cap, crushed on the road, would take on a certain luster when polished and become a tasty by-product of highway beautification. Railroad spikes, pliers, spigots, stopcocks, saws—I probably had half a ton of these things. They were my Rossignol skis, my Bass Weejuns, my Pioneer amp, my Jack Kramer tennis racket, my subscription to *Esquire*. Though I understood very well why I *should*, I did not in fact have an MGB secretly garaged in town, no Brooks Brothers shirts or Sperry Topsiders, no perfect smile or cheekbone high, but I had this:

And this:

A "SUCCESS GRINDER," that's what my collection was at the time, a means of grinding out my own Horatio Alger Hissence. To anyone who looked in, I might show off these precious things as if they were quaint netsukes or autographs of all the American vice presidents. At these moments, I could feel myself becoming "a character," but at least I had an identity and rightful property and a realm, as befit a King.

My first year at Andover was the last in which boys were required to attend daily chapel and wear jackets and ties. My last year there was the last in which the school was all boys. In a sense the boys' school itself came of age in those years (1968–1973), and there were regular recesses for revolution: against war, against racism, against class privilege. We were privileged to defy privilege. The office in which records of class-cutting and demerits were kept was ransacked, institutional symbols were vandalized, Latin and Greek were called irrelevant, and the student president was suddenly Black with a capital B. The weekends, and later the weeks, were filled with drinking, drugs, and joyrides. And that was just the faculty! It was not an easy place or time to be a good boy.

ONE SATURDAY EVENING I avoided the vortex of misbehavior by staying in my room and reading a class assignment, Eugene O'Neill's *Long Day's Journey into Night*. I read it straight through the evening, slowly and carefully, to steady the pain and sustain the joy. O'Neill, through his autobiographical character, Edmund Tyrone, gave me a way of comprehending my own

39

feelings about being face to face with madness, experiencing a sudden loss of family wholeness, and knowing the loneliness of having, inextricably interlaced, sympathy and vengeance, innocence and guilt, love and hate. My next collection became the set of every book I could find by or about O'Neill. From them I learned the laws of gravity. To be grave was to have identity, and the more O'Neill (and heavy metal) I owned, the better I knew myself—in-a-gadda-da-vida, baby.

Furthermore, I learned through O'Neill that art could be a conduit for life, since he was relentlessly self-reflexive in his dramas. He had suffered a traumatic childhood, with a mother who was depressed and distracted, a father who was a show-off and a drinker, and an older sibling who sent mixed signals, love and hate. He had coped with the pain and joy of being sent away to boarding school, as well as a distressing rift within his family during his teenage years when he discovered his mother's morphine addiction. If only I could be as constructive with my long day.

Late in my senior year I entered twenty-five of my O'Neill books in a school competition for book collections. The rules called for selected volumes from one's personal library. At the time I submitted them, I remember looking at my collection alongside those of other students and realizing I had no chance because my books were all worn out. Many were used when I bought them, and then I had read them so many times that they were creased and stained, while the other students' collections featured fine bindings never cracked. It is a paradox that use degrades value, that what is most precious is the untouched object. I had touched my books, and they had touched me.

I did have one rare and relatively unused book. Midway through my senior year I became so obsessed with O'Neill that I needed to have something he had touched. I wrote to an antiquarian book dealer and ordered the least expensive signed first edition of an O'Neill play. It was a play I had never read, *Lazarus Laughed*. When I received a slip telling me that a package had ar-

rived at the Andover post office, I ran downtown immediately, retrieved the small box, and ripped it open in the parking lot. Turning to the signature page, I laid my finger on the name, Eugene O'Neill. Contact! My hand was in the place where his had been. Magic! Then I put the book back into its slipcover and back into the box in which it had been mailed and took it to my room. Pulling out a cheap reprint of the same play, I proceeded to read it and realized that *Lazarus Laughed* was a terrible play, pompous and silly, the worst of O'Neill, and I had already read some very bad O'Neill.

I had some hope that this genuine first edition would give my book collection at least a little stature in the library competition, but as it turned out I had placed the book into the carton still encased in its cardboard mailing sleeve, and the judges had not even seen it alongside the dog-eared paperbacks. When they returned my books to me, the rare volume was not among them, and it was only after going through some discarded boxes that we found the book at all. At the discovery, I laughed. Miss MacDonald, the school librarian, who had always been kind to me, was horrified at the near loss of so valuable an item and surprised that I could be so heedless of it. But in truth the book did not matter to me very much by then. I have always, ever since, kept it in that same cardboard sleeve, and the fact is, right now, I cannot find it. Maybe I made the same mistake as the librarians and threw it out.

FOR MOST COLLECTORS, those who operate in the marketplace, the objects they value speak to many; hence there is a market. Collectors know each other through their stores, catalogs, Web sites, price guides, how-to books, and clubs, all of which constitute a society with a common interest, albeit also a realm of market cornering and hostile takeovers. Collectors often regard each other like members of a family gathered for the reading of a will.

I have long known I was a collector, but I recognize now that I am not the same as other collectors. My own collecting is different because I refuse the object that cries in the marketplace. I respond to the mute, meager, practically valueless object, like a sea-washed spigot, its mouth stoppered by a stone. My collecting is perverse and paradoxical. It is still collecting, especially as it corresponds to the compensatory pattern widely observed among collectors, the making up for love lost, but my collecting answers to a different god within the object. In a sense, I'd call it the god Not-There, the absence of immanence. What I like is the potency of the impotent thing, the renewed and adorable life I find in the dead and despised object, something in nothing. I am held by this divinity, and I like to think there is warmth there. Still, when I stand back, I see very little amid all the stuff.

When I meet someone I often ask, "Are you a collector?" And they often tell me they are and then show off a shelf of Joyce, a closet of T-shirts, a wall of silhouette cutouts, or a nook lined with Russian ikons. Old baseball cards tend to be in safety deposit boxes, while old stock certificates might be in shoe boxes. The latter you would have only if the company went bust, while the former might be worth a minor leaguer's salary. What I share with all collectors is a fascination with property and the ghosts that inhabit an object (the slugger, the CEO, the printer, the former owners, the dealer, and the many others who might have wanted to be owners). Possessing a new object feels like learning something or meeting someone, and there is happiness in that. But in my case the knowledge gained is not very useful (I'm not a collector of Caravaggio or Cartier or cartoon cels), and the experience of meeting is awkward. My objects are surprised to find me at the door.

A collector of collectors would find me rare. With my peculiar strategy of collecting, I become either the wisest of investors (of nothing) or the greatest sucker (possessed of everything except what I should want).

COLLECTIONS ARE NOT MERELY OWNED, they are performed. They structure your life and assign roles. As a teenager, I took to heart the role of custodian, which is different from owner. I was a maintenance man. A working-class uniform came with this role and helped to distinguish me from the other preppies. I preferred a hooded sweatshirt, serviceable shoes, Sears work pants. I did my rounds in search of things to tend, sometimes on a clattering bicycle with a rusted basket, and for me the golden pond moment was returning to my room, my janitorial closet with its scent of cleanser and polish. I would turn on the light, empty my pockets, and there discover how the new items looked among the old. I grunted with satisfaction when something new fit in well—iron sprocket over crumpled bumper chrome, seven brass finials in a crushed tin cup.

During my second year at the school, I lived in a three-room suite with a roommate. The building was one of the older ones on campus, and the room had a bygone elegance. Every object had its site, on the mantelpiece, wall, sill, floor, so the room had the look of a museum. My roommate was a popular guy, and our room was frequently the center of social gatherings. So word of my collecting spread.

Andover had two theaters, a large one that also served as school auditorium, a space of infinite dullness (George H. W. Bush, as CIA director and alumnus, had spoken there, to yawning indifference, and later on, so did George W.), and a perfect little black box theater called the Drama Lab. The professor who monitored activities in these theaters was virtually lost to intoxication and old age. He preferred the main stage, where antiquated and ridiculous productions were mounted, but had literally lost the way to the Drama Lab, which was down a narrow staircase into alcoholic vertigo. He passed out keys and full authority over this space of all possibilities to a few students, including me.

Under no tutelage, we experimented boldly in this lab, performing revisionist versions of all sorts of plays—necessarily

revisionist because we had no idea what had been done before. (For a performance of Marlowe's *Dr. Faustus,* we had no one who could learn the main character's lines, so a pile of newspapers on a platform stood in as Faustus, and his lines were spoken in voice-over, while the other characters strenuously addressed the pile.) I tried my hand at O'Neill, Pinter, Albee, and others, the meaningful writers, but then I discovered the wonders of Dadaism, an art that means nothing at all. Meaning nothing seemed like liberation to me, so I came to respect O'Neill, who was full, but to savor Tristan Tzara, who was empty. Dada was alien to my father, Dad, and even more so to my grandfather, Papa, my phallic figures, while I was just learning to babble like a boo-boo. Dada became my nada-thing-to-be-done-about-it doodad, my heart, my fart.

Near the beginning of my senior year, I used the Drama Lab to exhibit my collection publicly for the first and (so far) only time. My friend Bill pushed me to display my "junk," all the polished and unpolished odds and ends I had collected. In one of my trips from Boston to Canton, I wound up stranded at the Pittsburgh airport for some hours. I sat on the durably carpeted floor by a "sky check" stand containing a set of tags for various airports, each with its three-letter code. One of them was ORD, for Chicago's Ordley Airport, and that simple syllable impressed me as an American equivalent to "Dada." So I swiped a handful of those tags. ORD was the perfectly comical, belchlike utterance, expressive of nothing serious, of nothing, period, table scrap supreme. Taking up Bill's suggestion, I arranged my entire extra-ORDinary collection on four or five platforms in the Drama Lab, now the Ord Gallery, making a miniature sculpture garden of *objets refusés.* I sat on a chair on one of the platforms and invited anyone who came—and quite a few did—to ask me about any one of these things. These diddlysquats were of little interest and less account, but I free-associated, sometimes telling the story of where or how I found the object, sometimes what I liked

about it, inventing, confessing, always enhancing my valuation and, I hoped, my value. I was pricing myself higher than before.

I had come a long way from my beginning at Andover. I felt less an outsider, happy to be at the center of attention, however briefly, and yet still an oddity, a character actor, myself. My collection for the first time stood in for me, and I was its curious curator, a man with a bow tie and a lisp and a loupe, as well as its custodian, the guy with a rag in his pocket and a ring full of keys, when all I wanted was to be a lover, loved and loving.

One day, a girl named Sandy, of the neighboring Abbott Academy, did makeup for our production of Pinter's *The Homecoming*. She leaned over me to apply age lines to my sixteen-year-old forehead, and I caught sight of her perfect braless breasts. Moments later, I was playing Teddy, the impotent American professor, and I never saw those breasts again. Of course, I continued polishing my growing collection of knobs, gadgets, and thingamabobs, but it was Sandy's breasts I truly wanted to polish, much as I was regularly polishing my own anatomy. I wanted nothing but her sweet nothing. Meanwhile, smooth, lustrous metal was the best I could get, and far more impervious to continuous rubbing.

"NOTHING WILL COME OF NOTHING," says King Lear. On the contrary, I say, everything comes of nothing. It spontaneously appears on shelves and screens and strewn all over the streets. Nothing is a miracle! We come from the womb, where we have sufficiency, and suddenly there is a whole world, where we have need. In this day, we more oppressively fear that nothing will come of everything, or that everything fundamentally is nothing. Collectors operate out of a kind of faith (something Lear lacked) that everything is something, or at least that something is something. In my life, the heaviness is all.

AT THE END of each school year I would pack my whole collection carefully in boxes for storage in the dormitory basement

over the summer, and each year I had more boxes to load and unload. Before graduation came, I made it clear to my parents that I had a big problem, namely how to transport my collection to New Haven, where I would be entering Yale College the next year. I fretted over this. I kept emphasizing to them that I had "a lot of stuff," and eventually they got it that this stuff was vital to me. My father arranged to have it stored by a moving company and then transported to New Haven in September, but four months later, when the bill came, he was shocked at the cost. In this way, I became dear.

In fact, in an effort to lessen the cost of the move, I had parted with much: pound upon pound of bolts and nuts, saw blades, plumb bobs, lead sinkers, and sled rails, pitons and winches and bedsprings. Also a large sheet of glass that I used to weigh down and display a set of corroded metal strips on my desk top, and the strips themselves, which were like lines of cursive text, inscribed by the many cars that had run over them. Upon graduation, I did not discard these things but instead secreted them in the window well beneath a side door of the library. I thought that someday I might make a trip to Andover to recover these marginally precious objects. (I never did.) While lowering the sheet of glass, I sliced my hand deeply on its broken corner—no doubt the cause of its trip to the trash heap where I found it. For a moment I thought about going to the infirmary, but the prospect of having to explain the injury stopped me. I was actually deciding it might be better to bleed to death than to account for my hoarding. The scar is still visible.

This reminds me of a moment about a decade later, when I was still drawn to attractive metal objects though no longer nuts and bolts. One day I came across a discarded washing machine next to a dumpster, and it bore an eye-catching chrome insignia, NORGE. I knew I had to have this "Norge," such a queerly stunted sneeze of a word, an echo of ORD. I returned with a screwdriver and began prying off the chrome, but I slipped and badly gashed

my thumb. Still the Norge hung on. Bleeding steadily, I continued working until the piece came free, then I rushed home. My first thought was of infection, so I filled a glass with vodka and plunged my thumb into it. At once I fainted, and when I awoke it was in a puddle of Bloody Mary.

Thus sanitized, Norge went into the collection.

EVEN AT THE AGE OF EIGHTEEN, already a man of tonnage and a substantial bill of lading, I was yet an embryonic collector. What was the material world to me? The only unambiguous political position taken by O'Neill was a scornful attitude to greed and materialism, basic evils of modern life, in his view. But how could a collector not be a materialist? I reasoned that as long as my numerous objects were null in value, I could be no materialist, no matter how much I owned. I wanted my bulky life to pass for a rejection of "wealth" while retaining a passel of substance, much of me, just as his plays were scornful of the world but robust with him.

YALE WAS MY UNIVERSITY OF CHOICE because O'Neill had received an honorary degree there, the only degree he ever received. His son, Eugene O'Neill Jr., had been a student there and later a professor. O'Neill's papers were in the library, and Yale University Press had published *Long Day's Journey into Night*, for many years the only university press book on the list of Waldenbooks and other chain bookstores. At the time I applied, I still imagined I could take on O'Neill's magnitude by occupying his space, like touching his signature in the signed edition. Many years later, I realized that the entire extent of his time at the university was two, maybe three, days. Then I found that at Yale he was deemed a doubtful great. Harold Bloom would whittle his magnitude to a pencil point. Of course, by the time I was admitted to Yale I had read *Lazarus Laughed* and lost my own infatuation.

Haphazardly, I got a grounding in classics, read my Milton and Aeschylus and Shakespeare, tried my hand at Yeats, Kafka,

Donne, and Emily Dickinson, but it was the everything else that drew me to evasion. I loved to wander through bound volumes of *American Lumberman* from the 1940s, Saunier's *Modern Horology*, and Eric J. Dingwall's *Abnormal Hypnotic Phenomena* (four vols.). I got a lot out of *The Components of Synchronized Swimming* by Lindemann and Jones (the pictures look great if you hold the book upside down), also *The Flower beneath the Foot* by Ronald Firbank, and, precisely to the point, Henry Green's *Nothing*, a novel of nullity. My reading went athwart the university's hull. They assigned Chaucer, and I turned to the Nazca lines in Peru or Colonel William C. Hunter's *PEP: Poise—Efficiency—Peace*. If the call slip for a book I "needed" began with PR, I'd look for the book with the same number under RP. Reading, for me, became about not reading something that I should be reading, just as collecting became about collecting noncollectibles.

Eventually I delved into the errant poetry of John Ashbery, which sparked (what a relief!) not a bit of interest in his life. His poems were like taking walks on a strange road where new collectibles might be found. They were texts of the inexpressive self and nascent anarchist I had become.

MY SEMINAL WORK AS AN ARTIST was a series of "drawings," my "Full Boxes." I would take a fresh page of paper and rapidly draw a box, roughly an inch square, squiggle some lines in with a Bic pen to "fill" it, then go on to the next and the next, filling page after monotonous page with full boxes of Jackson Pollocky doodles. When I chanced upon a blank book, I started making a handwritten copy of the text least in need of copying, the Bible. I got through Genesis. Of course, I see now that the empty box and the blank book were emblems of . . . where I wanted to go with my generative (genital) power, other than into collecting.

IN THE SUMMER OF 1974, I lived alone in a cottage at the Chautauqua Institution in western New York State, the original

site for commonplace, commonsensical, holier-than-them-guys consciousness-raising. Artists and divines, ideologues and inquisitors had for a hundred years summered at this rainy resort to pursue Protestant enlightenment, nurture inhibited creativity, and rush to get in out of the storms that regularly blew in from Lake Erie. My family had free use of this cottage because it was owned by my grandparents, who had bought it as a school of sorts, a place where others, especially family, might learn to be more like them. My parents shielded us from the institutional lectures and sermons, in the hope that we'd grow up with a normal preference for the golf course just outside the front gate and the nineteenth hole to follow. Many summers at this cottage had inclined me to neither the lectures nor the links. What I liked were the worn bricks that made up many of the roads and sidewalks, also the steady quiet of a place too dull for dancing.

I worked that summer for the U.S. Postal Service, which had issued a 10-cent commemorative stamp on the occasion of the Chautauqua centennial. Stamp collectors from around the world sent thousands of envelopes to be stamped and canceled as "first day covers," and about eight of us worked for several weeks to complete the huge order. I was now on the other side of the stamp collecting business, simulating the standards we were told stamp collectors upheld—neat, clean, machinelike. My co-workers and I openly scoffed at the boobs who would cherish these trivial markers of time and distance as if they were rare, while we literally flooded the market.

For several weeks, I homebodied, reading Jack Kerouac and Henry Miller, writers whose lives bore zero comparison with my own. After each day of work, I puttered around. To putter is to potter is to poke around. The words express a mumbling, stumbling failure to get it said or done, "it" being a decisive act, a commitment of desire. My "it" was love in all its facets, and my puttering fell far short of that goal. I seemed unable even to know someone else. And yet. And yet, as an instinctual col-

lector, I knew that putting one object beside another, and then another, would make me feel I was getting closer to the cup. A putter moves the ball just a few inches or feet, but each stroke of the blade is as dear as a tremendous drive. Miller and Kerouac would whack the ball. Collectors putter.

Since Chautauqua dates back to 1874, many of the houses there are old, and the attics overflow with the off-cast goods of many generations, as well as countless bats. The latter kept me well away from my own attic, but I was astonished to see what treasures other residents would toss out in the housecleaning, after braving their own bats. Among the heaps of rotten wicker and rusted barbecue grills, I found jars of old buttons and boxes of Polaroid snapshots. The very cottage I was living in was a repository of the lowly manna of the material world. It had been purchased by my grandfather, and he was one to save things. "Scotch blood," my father called it, the tendency to preserve a bent nail in case there should come a day when the last straight one had been driven. My grandfather was no collector, but he was a keeper. The cottage had shelves of books of the sort no one would touch, racks of twice-thumbed magazines, Folgers cans of useless hardware, shoe boxes of obsolete fixtures, contrivances, and contraptions standing by for jobs never done, and odd tangles of fishing tackle, pipe, wire, and thread. There were also catch-all drawers filled with "string too short to save": teensy pencils and leaky pens, spare parts for discarded appliances and discarded parts from spare appliances, and every sort of gimcrack loblolly lumber.

All I had in my impromptu summer collection were diverse objects distinguished as a group only by the fact that they were found, not bought. Certain of the objects now bring back such feelings that they could be called souvenirs, a word which literally means memories. I can still recall the fading light underneath tall oak trees and gray summer storm clouds, the heavy humidity, and the distant trickling of the creek at the trash heap

where I hit the brakes on my bicycle and arced around to retrieve those jars of old buttons. Much of my storytelling in the Ord Gallery exhibition had grown from this sort of recollection of things past. By seizing these tokens I was creating for myself a lucky and joyful history, those times when I found rather than lost.

Still, these doodads were more than nostalgic objects, and I was already operating beyond souvenir hunting. I was seeking something adequately low to constitute a world I could stand above, my kingdom, lordly over it. What made my chicken scratch into collecting was the fact that there was a category I was trying to fill, and that category should cohere. It could be called Things That Are No Things, or Nothing. The means of organization had to do with a personal experience of nothingness, coming from hollow afternoons, uneventful evenings, and nights alone, all of which I attributed to my having nothing to speak of. I was, after all, trying to guard against becoming a Person Who Was No Person, a common adolescent nightmare. Since I could not (easily) have something, then nothing would be what I'd want, but I'd always have to have some nothing to distract me from the fact that I never had no something. Is that clear? In any case, the exercise was not purely abstract. At the time, I thought I was collecting fragments or metonyms of my experience, individually useless, which put together might display a rich life. Think IKEA. Assembly required, the appropriate Allen wrench and art. I would also eventually require psychoanalysis, a big hug, lots of time, and luck, but art was the only thing I even began to understand back then.

In terms of art, I could see that individual items of my collection had increments of aesthetic value, some a lot, some only a little, and it seemed logical to me that if I could just combine, amass, sublate, I would produce cumulative value in the form of art. On the other hand, joining the pieces together seemed inevitably to involve limiting the usefulness and value of each object, since other possible combinations, and above all the possibility

of keeping the pieces separate, were thus eliminated. I wanted every cherished piece of junk to be separate and unique, as I was, and also joined together in the Great Society, a coherent and improved world. I embodied the liberal paradox, slightly rusty.

It was about this time that I first became aware of the boxes of Joseph Cornell, the reclusive American surrealist artist who from the 1920s till his death in 1973 created fanciful, nostalgic worlds inside a series of beautifully crafted shadow boxes. He too had gone to Andover, and then retreated from the world into his art. All of his boxes contain found objects—toys and figurines, pages from old books, shells, feathers, tickets, locks of hair—all in a coordinated mythic system, which was the subconscious mind of Joseph Cornell. He had made strong decisions about fixing his fragments in place, sometimes even partially destroying them with paint or glue, and the shadow boxes' glass outlawed touching the objects, which I wanted to do. Still, the pieces were wonderful. One exhibit of Cornell's art that I saw was mounted by Tiffany & Co. at Leo Castelli's gallery in Manhattan, and each work seemed a fine jewel.

I knew that anything I might create would not be so exquisite because I lacked the craft, because I would never stumble upon such once-scarce, now-rare raw materials, because if I did come across such valuable objects I would find it hard to use them so boldly, and because Cornell's assemblages could fascinate but not express me. My aesthetic, if it could be called that, was cruder. The best I could hope to make would be what is now called "outsider art," the stuff that gets created despite and beyond the system by which Art is certifiably made and evaluated. I was in a bind, however, because I was taking courses in the history of Art, and I had been to Leo Castelli's gallery and other such places. How could I now make naive art?

That summer at Chautauqua, I built myself a box, the size of a suitcase, out of scraps of discarded wood. I was going to make a little world you could lift the lid on and peer into, in which

each collected object would be permanently positioned at its optimum angle (as if on 100% Irish linen). I poured wet plaster into the bottom of the box and set in place a number of chosen objects—chosen from among those I was least worried about wasting. However, I had not figured on the difficulty of keeping each carefully polished piece free from smeary plaster. I had not anticipated that the water in the plaster would cause them to rust. I had not foreseen that I would mourn the loss of each stupid whatchy—lost to art. Instantly, I detested what I had done.

By Cornell's standards, it was a complete mess, and even by mine it was pretty hideous. I tried to love it, but the best I can say is that it expressed me in all my frustration, like the "Full Boxes" or my Andover psycho single. Again the empty box, filled with gunk; again the tokens of my fortune but nothing I truly valued; again the consolidation of my world in a form that estranged and embarrassed me.

POOP. The analytic literature about collecting is full of it—the urge to retain, expel, transmogrify, to clean up a mess, to manage consumption at the back end of the deal. Muensterberger:

> It is certain that a child's early experiences with excretory functions have an influence later on the adult's ways of giving and taking, of holding back or letting go. Building up "heaps of things" in a collection or piling up money or amassing rubbish such as old newspapers, empty beer cans, or discarded umbrellas, in addition to equally useless items (as I had an opportunity to observe in an aging spinster), often clearly and quite understandably functions as a bulwark against deep-rooted uncertainties and existential dread.

Anality is not a subject I enjoy addressing, but it has its place in this story, and the memory of the rust-stained, gooey plaster in the bottom of my Chautauqua box (a sort of outhouse), where

I had placed some of the shittier pieces from my hoard, makes the subject unavoidable. As a teen, I played out the role of young Hamlet, struggling with my father, or various figures of my father, to establish some identity. While my father was loose and unbounded, I became tense and contained. I stuttered a bit. My language did not flow. I had performance anxiety in life, which disappeared magically in art, initially theater, later writing, music, sex, and collecting. There I could be fluent. There I knew my shit.

I know that many collectors, including myself, cling to "compensatory objects" in answer to early trauma. If human objects have proven unsteady, material objects might stand in. Collectors resonate unforgettable breakage in the shell of love, which encloses the embryonic self. Muensterberger:

> To put it in another way, such a person requires symbolic substitutes to cope with a world he or she regards as basically unfriendly, even hazardous. So long as he or she can touch and hold and possess and, most importantly, replenish, these surrogates constitute a guarantee of emotional support.

Thus, collecting, and specifically its active component, the iteration of owning, acts as a form of recompense and a means of survival in a hostile world.

THE CHAUTAUQUA BOX survived for a decade in my parents' basement, the place of sewage, and I blushed whenever anyone asked about it. At last, with my consent, they threw it away, and I was glad to see it go. The box was an important point of discovery for me, because I realized the difficulty of making beauty out of my objects. It is not easy to collect "out of the box," because the box is the coffin of old time, which is what I had to live through, as best I could. Whenever I visit a flea market, I detect the same confusion of effect. A table filled with tin advertising signs, empty Coke bottles, or old calendars dazzles the eye with

color, form, and graphic effect, yet the stuff is still refuse. An old Burma Shave ad cannot sell a vanished product, though it tries as hard as ever. A massive binder of plastic-sleeved baseball cards makes for an impressive panorama, but the images are hardly masterpieces of photography, the statistics are better found elsewhere, and you cannot escape a whiff of pink gum. Baseball cards will never win a World Series or a war. Collecting constantly exclaims a series of losses. An old clock in a collection does not so much tell time as it tells of time, and the tale is a sad one.

Collecting is silly enough to make a mockery of the great engines of modern life that generate all these things, brand names and commoditized social rituals and mechanical simulations of craft, all the substance of existence within capitalism, featured for a moment at a premium and then normally discounted, discarded, and broken down. Ironically, the thing that sold worst originally, or the thing that was most easily broken, will often become the most prized collectible. The most valuable edition of O'Neill's plays is the first book he ever published, a few hundred copies of which were privately printed by his father. It was generally neglected and contains plays he later repudiated (they are bad!), but now it's worth thousands. Collecting frequently brings out an absurdity within the system, that value in the free market is free to overperform. Collectors scan for those moments when the material world goes batshit, and there they lay their maggots.

The fact that the Chautauqua box lasted a decade in my parents' basement was remarkable, because my mother is a great believer in the virtue of "clearing out." I lost a sack of old marbles (not just aggies but tigereyes and puries and onionskins), a big pile of *Mad* magazines (albeit tattered), and many other jewels throughout my childhood. Trash picking was a survival skill in our house during my mother's clearing-out periods. Cleanliness often squares off against art, or warmth. Even our beloved child-

hood treasures could be swept away, so no wonder we groped for connection. To this day, I sleep under a blanket from my boyhood, which I snatched from the trash can.

Why, I later wondered, had she *not* chucked out the Chautauqua box? Oddly, I think she felt it was valuable because I had made it, and there I was, craving the resolve to clear it out, to flush it. Certain things cannot be borne: one's blazing failures, bad art, excretions. And yet there might be something there.

Ambivalence is not fostered in the family.

{ III }

NOTHING REGAINED

My love life did not include myself. From the beginning of my college years, the first two or three days of which I spent sitting on the windowsill of my first-floor dormitory room, I positioned myself outside the realm, alone. The college president was named Kingman Brewster, while I felt myself neither king nor man. I had brains and sinew, but I lacked Skull and Bones and everything the least bit Sterling. How had I happened here?

The first thing I needed to do was collect myself.

When my boxes arrived from Andover, I found little or nothing among those once-cherished, now-tarnished metal objects that would stand up to the question of who I was to be at this university. I was instantly aware that a whole new degree of polish and preciosity would be required. Studious habit led me to fall back on reading, and I read from the core, meaning the books stored deep in the inner stacks. I liked the ones that had not been checked out since 1946 or 1906, the ones with long titles

and stern portraits on the frontispiece. I lost and found myself in remote topical aisles of scholarship-wreck.

Many a night I hauled my Smith Corona typewriter, originally Cindy's, to one of the small seminar rooms on the top floor of a building once occupied by Nathan Hale, and through the night I read and wrote—and smoked. Pipe smoking had been permitted to seniors at Andover, but not in dorm rooms. I had stretched the rules by leaning my head out of the third-story window and smoking into the small hours of the morning, my combustible dream life. I had a great tree to stare at, also stray dogs, cats, raccoons, and an occasional student seeking a place to pee or vomit, all of which I regarded in silent, smoky rapture. I continued this habit of late-night smoking at Yale, but now it became laced with the world of words. The little rituals of cleaning the stem, reaming the bowl, packing the tobacco, lighting and relighting, helped create a rhythm of reflection and attack in my exercise of the typewriter. The papers stretched because I did not like to stop.

My 8:00 a.m. math class took the brunt of this new routine. I still have the notebook from that class, where pen marks, trailing off the edge of the paper, read like Cartesian graphs of my declining interest in all types of science, even rationality itself, and skidding off to non-Euclidean sleep in class. I would never be the doctor I was paternally urged to become. Many of my fellow students were making similar realizations, replotting their own equations. I discovered friends among them, drinking buddies and card players and a few fellow misfits. Love eluded us all. I remember reading Plato's *Symposium* my freshman year and regretting that this inquiry into the nature of love could only be idealized for me.

At the time, the theoretical trends around the university came from two sources: psychoanalysis (which doubted surface and credited depth) and deconstruction (which doubted depth and credited surface). Combining these approaches, I treated

the nothing as everything and the everything as nothing. One semester I sat in on Harold Bloom's course on American poetry, and he nattered on about the "anxiety of influence" American poets operated under, about the terrible burden of the past and the struggle to overcome it, about how few writers were able to succeed. Those who did were the "strong poets." What panic he provoked in me, this man who could quote whole epic poems from memory, while I routinely failed to complete reading assignments. Every cell of Bloom's corpulent mind was packed with "strength," his favorite term, while my bulk was the lavish vacuity of Full Boxes, Fluxus, and *American Lumberman*, weak tea for a word's worth. Bloom's take on literary history was about fathers and sons in a struggle for immortality. For me, Bloom himself was the father figure (physically not unlike my own father, a stout, jowly man) and I was Stephen Dedalus, unable to get out of my own labyrinth, like the calculus of 8 a.m., when poetry hardened into fact. With such fathers, I shied from battle over anything, because every battle was a battle over everything, and any battle over everything I knew I would lose. (Consider the guilt of greatness!) Instead, I would fight for nothing. What I was missing was the middle ground, the female body, the something in which I could locate my nothing, the nothing into which I could stick my something.

Was this just the classic anguish of an advanced teenager who wants to get laid? On some level, yes, I was a late-blooming tomcat, finally on the prowl, but an extra demon tormented me, fear of what I might get. I had seen my sister naked on a few occasions, but those were all disturbing. A sudden overpowering urge to visit the bathroom would lead to her outcry, then a clamor of metal and fabric to get her to the toilet. A brief glimpse of fur and worse would knock me flat before the goddamned door could be slammed shut. Doctors see that sort of stuff all the time, doctors like my father and grandfather and eventually both my brothers, but not me, Nondoctor Dave. I could not see

that empty V, because even before she became a Medusa, I was determined to be the cock of the walk—king, man, rooster.

After being at boys school for four years, where I got nothing but a downblouse peek at a makeup artist's boobs, I had to tell myself that I need never be sucked into the nothingness of Cindy. I was healthy enough to know that corporeality could be very good, sane enough to know I could make it even better with my incipient wish for love. My father's medical books, a rack of them, vintage 1940s, had given me some Latinate handle on the facts of life, which was all about undisclosed parts. If only I could collect those on my voyages! However, the family perspective on parts was in a textbook of pathology, not sensuality. The men in my family devoted themselves to the defeat of disease, each responding to suffering with a treatment, if not a cure. Perhaps I alone found suffering to be a fitting response to life, and sex a means to oblivion, solo by necessity, conjoint only in fantasy.

At the time, Yale women, far more than my Andover classmates, seemed worldly and wise, while I felt homely and naive. Freshman year, a girl—a woman—named Carol, lived across the quad, and she was an artist, smart, soft-spoken, and sensitive. She seemed like the perfectly realized painterly expression of herself, as if she had been created on one of those days when every brushstroke came down right, and yet she was not static. She unfolded in time in a way that was exactly what anyone would want, with a kind of self-possession and inner calm I could only envy. I talked to her on several occasions, and she listened and responded in a way that sent me a hopeful message about the civilized world and its good dialogue. Only, I feared that I was not of that world, that I lacked a silver key to the Yale lock.

Early in my sophomore year, I saw walk into the dining hall another beauty, the woman I knew I wanted. She too was on that upper tier of sophistication and knowledge, but I could sense an agitation in her, a wound that made her accessible to me, since I too had a wound. She also had passion, humor, and soft, coun-

tercultural clothing. I quickly learned that she was a poet, and in that instant I became a poet too.

To be a poet is *not* to be a theorist, and so I knew instantly I was not to be a theorist. Soon I was in her workshop, and not long after I was in her pants, and that could very well have been the end of my collecting. I had her attention, if not her love, and she wanted to know all about me. I began to feel slightly substantial, though I was constantly in fear of running out of whatever I seemed to her to be. For hours on end, sharing her slim bed, I drew on my Ohio tales, as if I were (wishing I were) Sinclair Lewis or Sherwood Anderson. A certain bluntness was the gist of my infant verse. It turned out my poetry was more than just a seductive ploy. By means of poetry, words could become collectible. "Say it!" said William Carlos Williams. "No ideas but in things." Of things, I had loads, and now words.

Unfortunately, the poetess was just then learning to scream—as in Janov's "scream therapy." Within minutes of the moment I first touched her blessed everything, she was in a car to New York to spend a week at the Janov Institute, screaming out her anger, not at me but at her father and men, leaving me with my nothing and my waste of shame. I had been well on the way to becoming just that thing, a man, for which she had such venom. A handful of chestnut fur and a distant female scream became absence and more of a longing than I had ever felt. How could I fill the gap? With words, inadequate, or objects, imprecise, love remained still nebulous.

Fortunately, she came back from the rubber cell, still pretty and clever and a little horny. However, she was soon to discover she did not want *any* man in her pants. I had not made the journey to New York, but there in New Haven I was screaming too, in my own way. I wanted something quieter, even mute, in my art and my relationship. I wanted beauty that was inanimate, perhaps to capture that deadness, the nothing, in me, and stave off the shrieking she-god, Cindy. So I took a course in sculpture,

which proved to me that I had little sense of three-dimensional form. Still, I utilized the class to work with found objects; I made impractical things aggressively and talked about them well. In one case I wrote a lengthy analytical essay on my piece all over its surface. By this contrivance, and nothing else, I became a conceptual artist.

Then, by some miracle of the kind customarily bestowed on elite university students, I was given a wonderful two-room studio, a medium-sized room with a small inner room. I named this suite the Sculpture Office. On the wall I hung a hand-lettered sign, "We Don't Make Art, We Administer It," because these rooms became a place for me to manage my collecting. Having an office made me feel like an ironic version of my father, which was the only version of him I could tolerate. As a Dada industrialist, I walked or bicycled for hours around town or along the railroad tracks, bringing back worthless things to transform into "sculpture." Whenever I spoke this word, I rolled my eyes, because to me it evoked those tricky crafts of modeling clay or chiseling marble, which I have never even attempted. The reality is that I balked at buying materials, since, after all, a great deal could be found, though it might be stuff of the sort called worthless.

I collected discarded chairs—broken ones, usually. I liked their handicapped look, their pathetic failure to function: fractured legs, bombed-out seats, arms akimbo, and always that headless, blank look. Yet each one begged the form of a human being. I arranged and rearranged them, piled them high, *contrapposto*, flung them apart, *helterskelto*. I propped them upside down against the ceiling with long poles, so that walking through the office was like entering a jungle where the canopy was all broken chairs—aluminum, wood, steel, plastic—ever in danger of clattering down, a rain forest of ruined furniture. I collected pictures of chairs and writings about chairs and translations of "chair," and I thought day and night about chairs.

Only one chair did I construct, a folding chair about ten feet high. It was just the structural outline, no seat, no back. It could not function for anything except my intention. I also crafted it badly, so it leaned. Nevertheless, I featured it prominently in a show I called "Chair Show," in the university's gallery space, where it dominated the rest of my chair family, including this sestina, which had sprung from me:

My Sister's Chair

Could this be the one that rose up and turned
around in her dream? And when it came down
she could not walk again. The chair had made
her sit, she said. Now she sometimes sits for five
days and makes no sense, dangling her legs
in strange water, because the matter struck her sad.

The warp in a good board will make a maker sad;
those dumb dry cells, swelling with the flux, turned
the plane. But I found such boards fit for the legs
of a mammoth folding chair. If it huddled down
on one corner, so what? Who would sit on a five-
fold folding chair, anyway? And thus it was made.

When it rose ungainly above the crowd, it made
a scene. I looked up, too, though it left me sad,
such a sullen lump, like a family Ford with five
flat tires, but louder than some Louis Quinze, turned
like a teacup. This was a chair that could look down
on the Platonic form of chair. I called it Daddy-longlegs.

When I was small, only up to his legs,
my father dragged her up the hill, which made
her almost happier than going down
on the six-man toboggan. But she grew sad

when she wanted to learn bridge. Her face turned
red when I helped her bid, and then she went down five.

My father found us wide awake around five,
head beneath the pillow, hands between my legs.
He told us not to worry, as we did, and my brother turned
the other way and cried, because dad lied, and this made
her words hard to hear, but I knew the man was sad
and that a crooked little woman was tumbling down.

Tonight, when the artworld chair comes down
to zero sum, I'll look with shame on my five
fit senses, four good limbs. I should feel sad
to trash my looming *objet d'art,* to see her legs
in splinters, but study tells me I really made
a slam. A finesse so deep could not be returned.

Turned out it was not growing up but knocking down
the milk-white maid that made the poet's five-
league boots, with legs so warm inside, forever sad.

Turned out the bedtime tale was all about how down
to the bone it made the middle finger of the five
and of the legs the third, the one so freaking sad.

The lord has a way of pressing down, forcing apart the legs.
Ask the foolish, unoiled virgins five. The oily ones all made
their buried thoughts return to a heaven never sad.

A distant mother settles down, expresses art between her legs,
a family of five, minus a cracked-up sixth. Which one ever made
a love that stays and the chair that turned my sister to me sad?

This poem was not like the usual stuff I was writing at the time,
which was coded and abstract. Here the core traumatic memory
of my life connects to a parable about survivor's guilt and the
inadequacies of art. The rare aspect of this poem for me was that

I had used art as a window on my self, because my taste ran instead toward hard, resistant, opaque objects, which I could create and collect without self-reflection, like the black wire rattrap I hung over the dining room table. Collectibles are discreet, even repressed; they don't tell the whole sad story, which is why they can be kept.

Rediscovering this poem many years later, I see now that I *envied* my sister's vision of the turn to madness. You might wonder how could I envy someone who had undergone such torment, yet that image of the exalted chair, the ascendant figure lit from below, revolving, still seems to me like a vision from Ezekiel, and it was *her* image, the apotheosis of her psychosis. I aimed for just the same effect—the mundane elevated—in words. The poem channels my Cantonian voice into an elaborate Italian verse form, with its intricate pattern of repeated words, so that I am both bumpkin and baroque. Three times the chair turns around, once for each brother. Six stanzas, one for each member of my family, crunch on the repeated number five, the family minus Cindy. *Chair* in French means flesh, and fallible flesh had made her sit in the large room, on a wooden office chair, like those in my father's waiting room. In the poem I confess myself to be my sister's crude imitator, her derivative, and furthermore her saboteur. My ability (associated with my masculine sexual potency, as well as my intellect and capacity for work) was charged against her feminine handicap (associated with how she got screwed, as well as her vagrant mind and capacity for anger), and the balance was this poem, hers as much as mine. "Could this be the one?" I ask, meaning this poem as well as the giant chair I had built. I wanted to make something big and extraordinary of her calamity, something truly beyond my powers, and I had not done it well in wood. In words, I would make up the difference.

Formally, the poem leaks at the bottom, at the place where it gets most violent. A sestina should end with one three-line stanza using all six words in the sequence of stanza one. "Turned

out," as the line says, there was no containment, and a lot of especially caustic material flowed out down there, as in a toxic waste dump. I had found the dangerous leak in my form, and it was right at the spot of my self-hatred, not a place I would care to go to in reality/illusion for the next twenty years or more. I patched that leak with denial.

All of my collected or constructed broken chairs were figures of my sister's pathos, and my attempt to make art of them obviously had to do with my being last man standing, the one who stubbornly remains, looking guilty as hell.

My sister lived the life of a broken chair, and by now that chair was often wheeled. At holidays, my mother would press me or my brothers to make the tedious drive with her to the Gruter Foundation in Wooster, where Cindy was housed. Here, at least, my sister had friends, and during the time it took to gather her things, sign her out, and walk or wheel her to the car, we would attempt to do what kids do in any family, get accepted by your sister's friends. However, the dialogue tended to stray:

ME: So, Cindy, are you excited about Christmas?

CINDY: Yes! We had a Christmas party, and I won.

FRIEND WITH A TINY HEAD: Goodbye, my Cindy-girl. (Belly laugh.) Cin Cin Cin . . . (repeats endlessly).

MY MOTHER: Where's your coat, Cindy?

ME: Did Santa Claus come to the party? And what did you win?

CINDY: Santa Claus is nothing not real. He's nobody nothing I swear to God, and you never should talk to him. He's hocus pocus, Andydaveypeter, get my coat.

BRISK NURSE (swooping in): Now, you all have a merry Christmas, Cindy, and save me a candy cane. Okay, girl?

MY MOTHER: Where is her coat?

CINDY: Okay, Miss Pocus. She's going to poke us with a cane. I can make it myself, if I try. I want sugar cane (rich amusement) from Mr. Calvin

Kane. The party is in the barn, you know. Over there, with the other guy, Peterandydavey. Were you invited to the party? (*Giggles uncontrollably, but worriedly.*)

ME: What party?

ANOTHER FRIEND, HEAVY-FOOTED, DULL-WITTED: I love you, Cindy, you and your boy. (*Howls of laughter.*)

CINDY: Where's the car? I gotta go. Right now. I need to go to the bathroom. I NEED TO GO TO THE BATHROOM, QUICK

And then, for some days, while she was at home, home became a space where it was hard to breathe, a space of aching need and self-pity all around. Often, after taking her back at the end of a visit, I felt *nothing* but dry tears and wet self-hatred.

True, I had had no real date by the time I was eighteen, but she had had no real date ever and never would, what with the top of her mind blown off. She had loved rock and roll, Chubby Checker, and "The Twist," but the twist she never did. Forty years later, she is a bottomless vessel of Thorazine and other antipsychotics. She is a ward of the great state of despair.

What happened to all the collected chairs? It turns out they lacked the immortality of a collectible. There is no great joy in surviving, certainly no beauty, and a value that is hard to share. Instead, there is mainly guilt. I kept only the poem.

AT A TIME when art mostly wanted white walls, I made art in a ruined world, a triangular chamber off the boiler room, a place so low it stayed flooded with a few inches of filthy water most of the winter, yet so high you could not make out the ceiling in the dim light. There I brought discarded Venetian blinds, which I suspended from the asbestos-covered pipes. These blank panels shaded two sources of light, a soiled basement window near the ceiling and a bare bulb in the boiler room. Light from the bulb reflected off the oily water; when the boilers were rumbling,

you might also catch a faint glow from the blue flames, and you could smell the heavy, leaded oil. At the highest, darkest, most distant point in the room, far out of reach, I hung a plain wooden chair from a single cord, which would twist slightly. This was the lovely misery I wanted to share with Cindy.

DURING MY SENIOR YEAR, I was chosen to be a Scholar of the House, which meant that I, along with a dozen even odder oddballs, would execute one huge independent project in place of all course work for the year. My project was to explore the art of performance. I wrote. I made objects and environments. I administered. At the end of the year, I created a series of four performances, given on four successive evenings. The core image of the series was an empty square in the middle of an empty city or abstract space, a framed absence. In the first piece, I entered the space from a side door, wearing wood-block shoes, wood-block mittens, and a wooden box over my head. I clumped in, carrying an old chair, which I blindly hung on the door. That was the high point of the evening, which otherwise meandered around stray poetic phrases, including one from John Ashbery: "The earth an empty square." At the end, I removed the mask and shouted at the audience to get out. Surely not the most delightful of evening entertainments.

The second performance centered on a square of green grass framed by bricks beneath a dangling grow light. For me, this signified contained nature, suburban lawn. Behind the grass, I sat on a wooden stool, hooded, masked, and robed in black, holding a square of clear glass. I said and did nothing during this performance, just listened to four others who spoke some words, evoking homely crisis. At the end I shattered the glass on the floor.

The third and fourth performances took place in a large, tiered lecture hall, with perhaps a hundred seats. Because this second-floor room had no fire exit, it could no longer be used as

a classroom and had been padlocked for at least a dozen years. To my surprise, I found myself in possession of a hacksaw, and in the room I found old time itself. A thick layer of dust lay over the old-fashioned school desks, the long lab table at the front, the wood-framed sliding blackboards, and a stack of unused blue books. Disturbing as little as possible, I absorbed the details of the room, unscrewed four school desks, which were used in the first two pieces, then closed the door, adjusted the padlock so it looked untouched, and did not set foot in the space again until the night of the performance. By then the dust was even thicker.

Here, in a lecture hall, I became a teacher. I performed "experiments" at the lab table. I dada-didacted. I showed loopy slides on a tattered screen in the corner. As in the earlier pieces, allusions to some obscure (oedipal?) crime or catastrophe could be heard, as well as some of the more tormented bits of introspection from Ludwig Wittgenstein's notebooks and fragments from the poetry of Wallace Stevens. Having spent many an "Ordinary Evening in New Haven," I adopted his phrase from that poem as my motto, declaring my performances and assemblages to be "intricate evasions of as." The third piece was lightened somewhat by the use of a quaint series of images from a book called Brain Tests, by John Monk Saunders, published in 1925. One page showed a series of small drawings, each containing an empty square. To the right of each drawing was a set of objects that might fit into the square. It was a pictorial multiple-choice test—and the origin, after the fact, of my empty square. In this puzzling set of images, I located a world that mysteriously contains the void in the midst of the mundane, crisis in the cozy home.

Looking back on this piece, I recall my anxiety about having no center, no identity, and I can see in the text, both in its evocations of "great minds" (philosophers and poets) and its self-effacement, an effort to overcome this anxiety. The picture here, for example, was accompanied by the following:

Good wife, your head, half
out of the picture, so
kind a look, too bad the table
cuts you off.

Did I slice my head
with this big butter
knife I'm tired of
carrying around? Look,
even now it pokes
the empty square,
and my head begins to hurt.

Why have we an empty
square upon our table?
What has happened to what
was there? And when?
We rarely leave the table bare.

It's twenty-three till
twelve. It's seven or eight
o'clock. The turkey's floating
off the shelf, and a banded
sort of bowler is
plastered to the wall.

The saltcellar's held
by some strange force,
and the cup, my dear,
hovers with the saucer
under the rising plate.

My dear,
beneath my huge, impressive
head, with its magnificent
black and white hair swept back,
the tablecloth cuts me off.

70

The table looks odd
at this angle, with the silver
stuck in place, and then
this blank appeared.

My finger is a fork. One arm's
grown too short and crookedly
presses on the table. The other
looks like a paper pasted down.

I say this is all intolerable.
We have no legs, no legs
on the table. I cannot breathe.
My thoughts are stifled.
I'm tired of Ohio, honey.
Let's blow.

Dearest husband, this is so sad.
I know that life is hard.
There is no room for my hair,
and you cannot move your chair
but it breaks the square
and enters on an abstract empty
air.
With my eyes above this line,
I see that my head here and the
tip
of your chair break through the
frame
to reaffirm the facticity of the
canvas. . . .

A catastrophe had come upon the family, and it took the form of an absence: something—or someone—not there. That absence had pushed the family out of its simple (square) container; the home no longer fit. I returned several times during this piece to a passage from Wittgenstein: "A *picture* held us captive. And we could not get outside it, for it lay in our language and language seemed to repeat it to us inexorably." For Wittgenstein, this refers to the deceptive nature of philosophical propositions. For me, it referred to an eddy, the defining vortex of my personality, Cindy down the drain, myself on the brink. Call me Ishmael, guilty survivor adrift on Queequeg's coffin at the end of *Moby Dick*. The sucking, sucky void had been amplified by my elite education, first by the pessimism of O'Neill, later by the nihilism of the Dadaists and the horrid/hilarious visions of Chekhov, Ionesco, Euripides, and *American Lumberman*.

Finally, though, if a picture held me captive, it was that insignificant scribble from *Brain Tests*, because only through it could I

connect to the melancholy of my situation, not the crisis of modernism but the sad saga of a mislaid boy from Canton, slightly overwhelmed by the world. My void was not on the main stage. It was not on any stage. Coming to New Haven, hoping to discover coherence and transcendent self, I instead found, "In every city, an empty square." My art, and later my collecting, seemed to repeat, inexorably, this emptiness, and I could not get outside it. I could only serve it, by trying to cobble together some fullness, some set of objects that would fill the empty square that was me, a real square in a hip world of art.

AFTER GRADUATION, I tried to turn my performance art back into theater as a playwriting student at the Yale School of Drama. Instead I was turned to dust by a simpering, snorting aerobics instructor, an iota named John Guare. He always called himself "the world's oldest promising playwright," and the world treated him well and not too well accordingly. To me, he was the world's worst teacher, and I was his worst student, and he treated me badly and very badly accordingly. There was a jerky rhythm in his step that said, "I really need this teaching job," and also, "I really need to make them think I don't need this teaching job," and also, "I really need to learn to like teaching," and also, "I don't!" It was like he was running away from us, to us, over us, all at once.

He snorted. Maybe he envisioned himself as a prize racehorse, giving the sidelong, big-eyed glare, shaking his mane, and snorting—a snuffly, no-kleenex blow—to clear his nostrils of students, little boogers. He torqued his upper body, to right, to left, jazzercising in a sweatless-Hamptons-boat-society way, Izod draped across his slack gut, while deriding his minions, playwriting pretenders of the Eminent Drama School of Eminent U, where he too had been an overeducated student, never a bit of dray horse in his background.

With a postnasal-drippy look, he attacked, ridiculing my every attempt to become his well-lit mirror. Then, one day, he

reduced me to zero, and I just sat there, before the others, dumb, turning hazy, then opaque, an early-onset cataract. He needed always to see himself better in his students, not to see his students better in themselves. He ran his comb through his hair to make sure we were never a tangle, never a stray. We were his gifted coif, and I not.

One night recently, I woke up from a dream: I am walking down a sidewalk, along a wooden fence, ducking the overhanging branches of many dusty bushes. A bus goes by. People are following behind me, and I am self-conscious about being watched by them, especially so because I am chewing glass. My mouth is full of shattered tumbler glass, and I am grinding the pieces with my teeth. I would like to spit out the shards. I don't like them in my mouth, which tastes bland and bloody, and I dare not swallow, but I cannot find what I am looking for, which is a recycling bin, a plastic haven for cutting edges. I keep walking.

I was not with them, those others in the class, having kept to my "crazy" corner, performing my empty squareness again and again behind many codes. Several others excelled at the art of playwriting and obviously would have a hard time "following" me, because of my featured lack. They also had a hard time backing me up once I got crushed, such a wilted zero was I. They looked on in horror as blood dripped from my mouth. They would become playful wrights, and I would knot. I would spend years grinding my teeth on this teacher, his brittle temper, his lacerating edginess, until at last I found the receptacle for this dangerous cargo and realized that this *daimon* was a recycle of my father, grandfather, O'Neill, Bloom, and all the unauthorizing figures of self-expression, strong poets in the presence of whom I was still accustomed to stutter and to taste my own wounds, my words, crushed ego. I cannot change my bitter memory of this teacher, but I know now that the obstacle to my speaking clearly as an artist was something hard to swallow in my life, not some teacher.

So I became the teacher I wished he had been. Through my late nights of reading, I had learned enough to use knowledge and ideas as a bridge, and literal pipe dreaming gave me the written word. In the ordinary way of a scholar, I became a collector of ideas, with a burgeoning set of books on all sorts of topics, and files that have long since exploded with notes, clippings, pictures, and recordings. While once I worked in a library, now I live in one. I have six or eight thousand books, a couple thousand recordings, and I often carry forty pounds of show-and-tell to my classroom. Collecting of that sort has served me well, and a few academic books have shared that bounty. However, I am now ahead of the story, which is riches-to-rags.

AFTER THE POETESS, in my senior year, there came another relationship, a much longer story, which held on for twenty years though it ultimately also proved evanescent. She was the woman I married, after ten years, and divorced after ten more. She was a fellow traveler in self-doubt, similarly wrestling with a sense of nothingness, and I was her poet, but what I wanted—and she too, no doubt—was something deeper than companionship, more basic than admiration: love. That clinging impulse, that relentless searching, that drive to fill an emptiness went for her into reading fiction, for me into collecting. The marriage was not bad. We were good partners. We provided comfort and security for each other. Together we fended off the more brutal assaults from outside, and together we created two wonderful children. I refrain from saying more about our marriage because of them.

"To have and to hold" is a resonant phrase for a collector. Every object that comes into a collection experiences that wedding ceremony and a certain consummation. We are born wanting to be had and held, born collectible, and with a little luck we never stop being prized possessions. But with self-knowledge comes self-doubt, and never more so than in the exchange that comes

with relationship, taking an other and giving oneself. Then the question of value kicks in. Are we in mint condition? How chipped is our binding, how tattered our jacket, how foxed our pages? Above all, are we dear? Collecting mimics love, and love mimics collecting. But even if we are prized by our parents, we do not know that for sure unless we are once in a while held up to the light. Held.

I have a battered Polaroid of my mother, not really holding me:

I have a battered Polaroid of my father holding me high, not close:

I have a battered Polaroid of Cindy holding me awkwardly:

These are the few pictures I have of myself being held, and they are battered, though I was not. I feel like an alien object in these snapshots, peering out from a disturbed world. I was not held well. Forever after, I would always be seeking some better hold on life and a sense of self less creased. Only after years of seeking another person to hold me and cherish me would I learn to cherish my own hold on life, thumb-printed, chemically degraded, time-worn, and cracked though it might be. The care I put into collecting gave me good training in valuing myself. Collecting would give me the practical experience of embracing—objects to touch, objects of fascination, wasted objects, unconditionally loved—and a way of sketching the world and my place in it. Unfortunately, for a long while, the only objects I felt I deserved were wasted objects because they reflected my wasted sense of self. The world was not a world I loved or in which I could feel loved, and so I withdrew into a world of fantasizing that my nothing might be all.

COLLECTING, LIKE ART, is a way of coming to terms with the strangeness of the world. It is a form of *wanderlust*. Hot desire wraps around the neck of someone who suddenly feels com-

pelled to possess, for example, all sixty-five known pieces of turquoise Fiestaware, including the rare "juice disk pitcher" (worth over ten thousand dollars), or the multiplicity of Pez dispensers, including the clear plastic "water pistol" (recently sold for over eleven thousand dollars), or the array of editions and translations of the Bible (leaves of the Gutenberg edition sell for more than fifty thousand dollars and a complete copy would surely go for ten to twenty million). Money is a key element in most collecting. Its flow, in and out (mostly out), is like the exchange that sustains life in a saprophytic organism—collector/collection. The compulsion to collect is a struggle against death, and in such struggles money becomes an unreality. The rarest old snuff box might be a magic elixir. Just as one might scout a casino floor to find a table that suits one's individual level of recklessness, collectors play the absurd game of deciding which scarcity to desire and how to claim its ultimate treasures. The overwhelming odds are you'll lose money at the game, you'll die in this life. Still, you have to put something on the table to expect any return. I played the longest gamble of all by choosing to ante nothing, again and again, at a table by myself. Jackpot might be jack shit, but the payoff would be mine.

(Do you see how, by repeating that bet here, in this book, as compulsively as in my collecting, I am beginning to beat the house? The odds—and the oddity—are now in my favor. We all win.)

Collectors are, as a rule, remarkably good at connecting or networking. They share among themselves facts of the arcane sort that eludes most academics, like the early history of the coffee can or tips on authenticating a first edition of a Zane Grey novel. Of course, they also withhold (or utilize, at crucial moments) key details that afford an advantage in the marketplace, like the fact that the spines of certain first editions of Robert Louis Stevenson's *A Child's Garden of Verses* have a "curved tail" apostrophe in the word "Child's," rather than the usual, recti-

linear hash mark. Capitalism demands a connected market and a disconnected shopper, and perhaps also an intuitively driven collector, one who applies special needs and knowledge to push a curved apostrophe away from its obvious channels. The collector's eccentricity might spur the adaptive market to respond to the swelling trend, in a way quite contrary to rational estimations of need. In the wake of this vessel, which is always cutting toward the current of fresh cash, come other collectors who detect residual value in the gurgling froth. It is harder to swim in this turbulence, but if you swim well, you get to see the weaker swimmers slip away. They SnapSell their Hummels or Mickey Mantles or Furtwangler 78s or Princess Diana Beanies before a natural buoyancy lifts those notable prizes right out of the foam. Collectors validate each other by proving that there are others who want or need particular collectibles, and the market sustained by the network assures value, which heightens the need to connect and expands the network. So close is the connection in some cases that the economy reverts to barter, with one person's need swapped directly for another's.

I hated instinctively that scene of competitive buying, since I feared equally winning (the guilt!) and losing (the anguish!). Anyway, profit was never my goal, and so, instead, I directed my efforts toward the zero-sum game. In effect, I eradicated other people from my network. My art proclaimed that I was complete unto myself and needed nothing. When I consider how ungenerous that message was to others, I am surprised I had any friends at all. When I consider how ungenerous that message was to me, I take a lesson in self-hatred. Fortunately, I felt that collecting itself, even collecting nothing, would prove far more congenial, more entertaining. It would eventually bring me connection and paradise regained.

Right?

{ IV }

NOTHING TO KEEP

Graduation was into the void, a world that did not require my artistic inclinations, and there it would be exclusively up to me to see that they did not lie wasted. With a BA in myself, I had no marketable skill but also no supervening appetite for power or position. I saw myself as one of those men from Samuel Beckett's stories whose routine, whose whole life, revolves around sucking a series of stones or tracing the cracks in the ceiling. Most of the time, with my little hammer and tongs, I would be making something of nothing, whistling while I worked in a breathy, tuneless undertone. Again it was the janitorial image I was trying out, the Rhodes-less-taken Scholar on a beat-up Huffy, scouting piles of refuse for something to fill his handlebar basket. I had the advantage of wanting little, wasting little. I could subsist on scraps.

One of the options I considered was moving to the real city, New York, the biggest empty square of all. As a performance

artist in 1977, I would hardly be ahead of my time. Indeed, they were at that moment becoming ubiquitous, and obnoxious. But I thought I understood a little of what was going on in that scene and could fit in. Blend a little bit of Joseph Beuys and a little bit of Mabou Mines and a little bit of Robert Rauschenberg and Vito Acconci and . . . and I would have been a lot of little bits.

So I stayed in New Haven and, in fact, became a janitor, living in a room above a nursery school run by a child development research center. This garret was free in exchange for six hours a week taking out the trash, raking leaves, mopping the front hall, etcetera. I enjoyed free, unauthorized use of the Xerox machine and all the toys after hours. For the summer, I was permitted to keep working in my Sculpture Office, since no one else seemed to want it, but my attic room was big and oddly shaped and well-suited to use as a studio. If only I could spend the day painting graceful nudes who would chide me with French vulgarisms! If only I could paint anything! At the time, instead, I was interested in what happens when you xerox a Xerox and then xerox that Xerox and do that again and again. A low-quality image gets lower and lower until it's just noise, a picture of nothing.

For income, I had a half-time, minimum-wage job in the Manuscripts and Archives Department of Yale's Sterling Library. I helped in the processing of manuscript collections. Some were collections the library had already owned; I simply transferred the materials into acid-free envelopes and folders and boxes. Others were new acquisitions. These I organized, filing and boxing the documents and taking notes on their contents. I preferred this work, submerging myself in the collected papers of one person after another—Dwight Macdonald, William Graham Sumner, Eero Saarinen—skimming their letters and manuscripts, labeling their photographs, experiencing the totality of a well-known person's retained existence, and then fitting it all into neatly labeled folders and boxes. Occasionally a collection, like a batch of ephemera from the 1939 New York World's Fair,

would contain duplicate items, and I was instructed to throw the extras out. I took care to discard a few of the extras in a trash can from which I could later retrieve them. By this method I also filched file folders and archival boxes (not acid-free, so discarded), which I liked because they reminded me of the collections they had previously contained.

One day I assisted in a huge project, transferring folders from the "morgue files," which recorded gifts from deceased alumni going back over a hundred years. They had been stored in old wooden file cabinets until it was decided that putting these little-used files in cardboard boxes on tall shelves would save much space. I was told I might take any cabinet I liked. It took me a while to piece together one that was sound, and it took much longer to balance it on my bicycle and wheel it over two miles to my room, but I loved having an authentic old repository. Now I just needed an old collection to repose.

Having strained under the weight of metal and the bulk of chairs, I could see the advantage of culling something small and light, but I still lacked the cash to purchase most "paper collectibles." When I did purchase something rare, it was usually a book and something I believed I could use. Whitlock's Used Bookstore soon led me to Whitlock's Book Barn, way out in the country, with thousands and thousands of categorized books, where I again grappled with the fact that to have anything like a coherent collection of books, in virtually any category, would require a lot more money than I had.

Instead, I made a regular practice of bicycling by another used bookstore. The store itself was up a narrow alleyway and down a musty basement stair, but it posted a small cart outside, filled with items free for the taking, as a means of attracting attention. Surprisingly often, something on the cart would strike me as worth significantly more than nothing, and so I would have my day's treasure. Many of these books, for example, John Gartner's *How to Build Trailers*, which gives floor plans and other

specifications for such trailers as the "Wander Pup," I have held onto ever since. I still enjoy paging through that book, but the relation of owning it to the usual practice of collecting is remote. I was not going to collect how-to books or guides to trailers or anything like that, but fortune made that worthless book mine for nothing, and so I have treasured it. (I just did a search of about ten Web sites for used and rare books, and I turned up just one copy of Gartner's book for sale, for $35.13, and that for an *ex libris* copy!). Mostly, though, this new pattern of scavenging left me with bulk but no value, volume but no distinction, property but no pride of possession, in other words, just what I had always had, a sweaty clutch of self-hatred. I wanted to be important, but I remained a Wander Pup.

THEN IT BEGAN, the first real collection of my adult life. One day I started to save the labels of all the food products I consumed—cereal, soup, candy, beer. I did not keep the cans or jars, only the paper or cellophane or plastic labels. Boxes and cartons I cut or dismantled. Everything had to lie flat, like a leaf in a book. Initially I glued each item to a sheet of paper, most of it reclaimed from some other use. Eventually, I decided to keep the boxes unbound, flattened but not cut or glued, so that they could be reassembled if the need ever arose. ("This is a national emergency. We require a Triscuits box from 1986, a *complete* box! Citizens who can fulfill this demand should report to . . .") I did not keep duplicates, but the smallest variations—new graphics, a new incentive deal or coupon, even a change in the quality or color of the printing—seemed interesting enough for me to preserve. Initially I kept the labels in my file cabinet, but soon began to punch holes and place the leaves in a binder. That way I was creating a "book," and eventually I would have a lot of these books. ("Of making many books there is no end," Ecclesiastes 12:12) Eventually, though I could not have said it at the time, I would have *this* book.

The genesis of this collection coincided with the end of parental subsidy. For the first time all my purchases were being made with money I had earned, and I can see now that I wanted to retain some token of my independence and expenditure. The small markets in New Haven, the ones within bicycle range (nothing "super" in sight), were mostly Italian-owned, mom-and-pop, and each provided a range of goods imported from Italy alongside the General Foods and American Home Products of my childhood: Kraft, Sani-Flush, Sara Lee, Mennen, and Pepperidge Farms. Although the imported goods were often beyond my price range, I enjoyed occasional ventures into Il Migliore Pear Tomatoes, Posillippo Rigatoni, and La Famiglia Cribari jug wine. These were walks in the wider world, beyond where I had ever been, and the labels were my snapshots. But I also toured Battle Creek, Michigan, via my breakfast cereal, Pittsburgh via my ketchup, and the ersatz Chinatown of La Choy. Camay, my mother's preferred bar of soap for us all, suddenly had no more claim to my wet body than Palmolive, Lux, Vel, or Zest. I approached labels differently now, with heightened respect and limitless curiosity. Instead of tearing them open, I inserted a finger along the seam and listened for soft severance at the glue points, the music of another label come to dada.

I got carried away by this new project and began riffling through trash bins for nice labels (by then I was living in a flat above one of those mom-and-pop stores), but I soon stopped that and more or less restricted myself to the record of *my* life and *my* consumerism. The bliss of processing also led me initially to paste in other things, like matchbook covers, junk mail, and paperback book covers, that I soon stopped collecting. I did keep the labels of some nonfood items, but the core of the collection has always been eating and drinking. And, for a while, smoking. And pet food and cat litter. And medicines. And hygienic products, like shampoo and deodorant, toilet paper, and my girlfriend's tampons. Lightbulbs. Sponges. Nails. And . . .

it is clear to me now that the discipline of the collection was virtually nonexistent. Partly I was driven by a desire to see my binders fill, first one, then two, then more. Within a month I was already *a prodigious collector*. Other people came to know of this and would save particularly nice wrappers for me, a carton from their favorite brand of microbrew from Scranton or a Darkie toothpaste box from Hong Kong. I never refused such a gift. Had they instead dumped the package after guzzling or brushing, I might have fished it out of their trash in any case.

Still, the core of the collection could be described as tokens of all that I had personally touched as a consumer, what I refer to briefly as labels. Whole marketing divisions labor over the question of how to situate this product in the public eye: with symmetry, asymmetry, blood red, royal purple, shocking pink; "New," "Improved," logo or no logo, slogan or blurb; rosy-cheeked child or elderly black man; photo of the product, watercolor of the impression, cartoon of the concept; coupon, clip-and-save, how-to pic; a little sex, a little sport, a joke, a jinx, a leering chicken, a smiley heylookeeme *nota bene* "over here, sailor" eye-grab. Printing presses have stamped ever more smashing colors, ever more gaudy graphics, ever more penetrating phraseology, onto cardboard, cellophane, paper, and PET, liminally and superliminally and subliminally enhanced by photos, foil, stickers, glitter, holograms, "magic pictures," celebrity signatures, games, contests, Hollywood tie-ins, free stuff, LPs, CDs, DVDs, MP3s, recipes, and scratch-and-sniff scents. As a result of these efforts, a certain chemical and physical and social and economical reaction took place when my hunger or thirst or need to blow my nose met this product, and that led to my purchase. Since packages generally conceal the thing itself, that reaction usually takes place right there on the surface of the label, in that swirl of color and connotation, where desire fuses with seduction, message with massage, hunger with lust. My psyche has been *there*, alert and rapacious, and the upshot has been that

my hand reached out. Political economy begins with that grab.

I was, in my early twenties, a member of a visionary, progressive food co-op, the sort of place where you begin your membership by listening to a lengthy Marxist lecture in the basement (rough draft of the manager's poli-sci dissertation). Four or five sidewalk sofas, discolored plaid, bare lightbulb overhead, Danish schoolbags, slightly damp from the afternoon drizzle, cigarette butts in coffee mugs—that was the décor set by the bored, proto-Gramscian co-op mensch, exhausted from a morning of haggling with wily cheese wholesalers and applying for tenure-track positions at elite liberal arts colleges. For an hour or so, the word "capitalism" got bashed around the basement like a Nerf ball. This store was not friendly to labeling, which was, after all, a celebration of surplus value, so a lot of stuff came from bins, none too clean. Of course, the New Haven Food Co-op itself was a giant package, but inside were scoops and ladles, towers of beans, vats of yogurt and peanut butter, wheels of cheese (purchased at a premium from those thieving bastard wholesalers!), and not much in the way of meat. To stock Kellogg's or Nabisco in this place would have been a crime against society. Jif was capitulation. Nestlé was murder. Far be those slick labels from me. Still, even in this store one could buy locally produced honey in a labeled jar or Dr. Bronner's Castille Soap, the stuff you could use to wash your hair or brush your teeth. Between the co-op and my cowardly, counterrevolutionary purchases from the library vending machines (Hostess, Little Debbie, Moon Pie, PayDay), I intercepted a steady stream of labels. If you leave behind the world of progressive food retailing, as I did when I had had my fill of the guilt trip and bugs in the garbanzo beans, then it is hard to find any unlabeled consumer product. Nowadays, virtually every vegetable or piece of fruit is individually tagged. Trader Joe's labels every single egg. Soon it will be every gene.

Some labels are inaccessible and a source of great annoyance. I have always disliked and dismissed wine labels because

they are typically stuck on with glue that is not water-soluble. After all, you would not want one smashed bottle of chardonnay to ruin a whole case. But you have to work hard, too hard, to peel off just one clean label. Worse are the new labels found on jugs of Cascade, liquid Tide, and many cleansers. You think you could peel them off, but they are fused to the plastic, which is sad because they are so garish and aggressive, even assaultive. I would love to have those hard-sell screamers in the collection. Very large cartons I don't save, also labels that do not flatten, like shrink-wrapped skins on bottles of exotic beverages, including almost everything containing ginseng. I do not save labels painted on metal (like many sardine cans and the gorgeous tins of Italian olive oil) or glass. Coke bottle collections are refreshing but require a warehouse. Mostly I save paper, polyurethane bags, cellophane, and cardboard. If a label is badly damaged I don't bother, but a little tear or stain or wrinkle is okay. Labels that have been in direct contact with sticky or greasy foods (like chocolate milk cartons or Crisco wrappers) I usually don't save, but some, such as bacon boxes, are so appealing I cannot resist, even at the risk of a little grease stain. The prospect of having a binder filled with bacon boxes was one of my early dreams and one of the justifications I offered when people asked why I was collecting this stuff. Wouldn't it be amazing to have a book of bacon? Then, a few years later, I more or less stopped eating bacon. Even so, I have thirty-five different bacon boxes.

AT FIRST, assembling the collection was just a matter of rounding up every label in my life, but I soon found my life itself was changed. When I went to the store for supplies, I scouted for new and edgy labels. Sometimes I made a conscious choice to pay more (or less) for a product simply because I wanted a different label. Instead of remaining loyal to a brand, even one I had always used, I started exploring all the other brands, and the crunchy as well as the smooth; cinnamon as well as plain; small,

medium, "convenient family," and jumbo (inconvenient family). A collection that was initially "about my consumption" began to shape my consumption as I became a self-conscious collector. I was trying to form an autonomous world in my binders, and this had come to mean encompassing the world of labeled goods. Of course, having every label was impossible. I could not consume (or ingest) the world but only the portion of it for which I had appetite and cash.

Still, when I bought soup, I thought, I want *all* soup, and even if Progresso's Hearty Bean does not agree with me, or Campbell's Scotch Broth appeal, still I must have those labels. And I do have those labels, through several successive generations of labeling styles. My soup label holdings are now approaching eight hundred examples. Once the FDA mandated inclusion of nutritional information on all labels in 1990, I knew exactly how nourished I would be by the soup or sauce or sardine, but my collection was nourished by the label itself.

When I bought toothpaste, again, I wanted it all. I have had my teeth now whitened, now cavity-guarded, now peroxicared, with gel and regular, mint, herbal mint, and "original," by Crest, Colgate, and a number of other dentifriciers. I've been promised "rejuvenating effects," "fresh confidence," "total protection," and other too-marvelous fantasies. Would my teeth look better if I had stuck to the one best brand? Who knows? (I wish!) All I know is that I have a twenty-five-year array of toothpaste packaging (120 different boxes), but hardly a complete history. I buy toothpaste maybe four times a year, and I have not always been the one to make the purchase. Sometimes, when my motivation is low, I use the same old brand and eventually throw the duplicate box away. But other times I'll think, Why not Close-Up or Stripe or Tom's? A store around the corner from me now sells toothpaste costing five or six dollars a tube, brands swimming upscale on the basis of their herbal enhancements or organic conciliations. I don't buy those, any more than I would an Eames

chair or a Tiffany lamp. My collection fits me more exactly, ordinary but extreme.

Cereal is the category where I have adapted myself most radically to the product. I am at the mercy of the marketers when I stand before their tremendous array of overpriced grain. Any new flavor, shape, puzzle, movie tie-in, sports celebrity, free toy inside, or CD-ROM game included is likely to draw my eye and motivate a purchase. I make it a rule, though, never to discard the cereal (or any other product) unless it is truly vile, like a few chocolate and/or marshmallow cereals (e.g., Post Oreo O's, rejected by me and my children alike) or a health cereal called Uncle Sam, which included whole flaxseed and promoted regular bowel movements. Mostly, though, when I buy, I eat.

Cereal boxes were my first literature. I spent virtually every morning of my childhood reading the box while ruminating on the cereal, long before I ever perused a morning newspaper. Cereal manufacturers have always strained to keep up the illusion that their puffing or flaking, sugaring or coloring, has enormously inflated the value of a handful of rice or corn. I once heard that it would be just about as nutritious to eat the Wheaties *box* as to eat the cereal, but the psychological boost of staring at a photo of the Massillon Tigers as you suck sugar through limp flakes should not be underestimated. It is the Breakfast of Champions, and I have always welcomed those heroes home. Still, if I ever lack for fiber, I have a supply.

I was surprised to discover a few years ago that Wheaties boxes have become part of the boom in sports memorabilia, and many of the older boxes have become precious. If I had my dad's cereal boxes, my mother's dolls, and a lunch box or two from my grade school years, I could summer in Gstaad, courtesy of those crazy collectors! Despite my best efforts to restrict my collecting to the worthless, some Total trash has accrued value. People have sent me articles about the prices paid for an original Shredded Wheat or the first Wheaties box featuring Michael Jordan (I

think I might have that one). I've read about a collector who saves the entire cereal box, including the cereal, in special air-locked rooms. Most of the other collectors specialize in one brand or category of boxes. Some, I suspect, go to fanatical lengths to get rare items and fill out their collection. As for me, I just have the boxes from all the different sorts of cereal I have spooned up over the past two decades and a half. Of course, I am a fanatic (from Latin, inspired by a deity, frenzied, from *fanum*, temple) in my own way. It's just that I am on the altar. My consumption is the point, or my reluctance to discard, and that has nothing to do with being a fan of Tiger Woods or the Chicago Bulls or needing every *Star Trek* relic or observing, socioculturally, how the word "sugar," as in Sugar Smacks and Sugar Pops and Sugar Bear, completely disappeared from the marketing nomenclature around 1990.

A Web search also turns up collectors of candy wrappers, full sugar packets, and beef jerky wrappers depicting NASCAR drivers, but I have not yet located a collector of Philadelphia Cream Cheese boxes or Doritos bags. Honeycombs does not figure prominently on the Big Board, ditto Frosted Mini-Wheats and Maypo. Few have attended as closely as I have to the labeling of mushrooms (I have a whole binder for mushrooms, with more than fifty varieties) or the tagging of asparagus. Some corners of my collection are peculiar to my travels, like the tamarind candy labels from Oaxaca (Mexico also merits its own binder). McVittie's biscuits, from London, are represented among all the other horse-feed cookies from Britain and the United States, but of them all are the most delicious.

Immense binders labeled "Candy," "Candy 2," "Candy Bar," and "More Candy" attest to my sweet tooth. A relatively thin book, "Prepared Foods," shows that I prefer to cook my food fresh and from basic ingredients rather than frozen or takeout. Soup is the exception. Andy Warhol brought forward the simple glory of a soup can, and that is a celebration I repeat in as com-

plex a way as I can manage, including a frequent return to To-mato. I will eat soup often just to snag a new labeling gimmick, a subtitle ("Hearty Choice," "Classic Recipes," "Chunkier"), or an enhanced view of the steaming bowl.

I cut as wide a swath as I can through the field of consumer products. Since, after all, I am shopping at Albertson's or Ralph's, not a five-star restaurant, I can afford to exercise my market po-sition freely, opting for the latest five-grain-*plus*-blueberry ce-real rather than someone's generic flake or, worse, the cereal that shows up naked and undocumented in plastic bags. My freedom meets itself in the mirror when I face the expansive limits of my imperial desire, and I balk at yet another new lentil soup because I know I cannot bear the flatulence.

At this point, I estimate there are seventeen to eighteen thou-sand labels of all sorts in the collection, and it continues to grow daily. There are also about five hundred crown bottle caps (the metal kind with crinkly edges), also kept in binders, in plastic pages meant to hold photographic slides. I recently discovered that there are other bottle cap collectors out there, especially in Europe. One Polish lady has a Web site where you can browse her collection of about fourteen hundred caps while listening to "House of the Rising Sun." I have several she does not have. She has many that I do not. But I have never bought a bottle cap as a collectible, nor traded with another collector. My collection reflects me and me alone, on the lookout, rampant.

It took me several years to find the bottle opener that does least damage to a bottle cap. It's a double-pronged, curved-flange lifter, and it was to me a vital piece of equipment before the era of twist-tops, though in fact I get most of my bottle caps from the sidewalk, because I rarely drink beer. Again, the nothingness I cherish dovetails with the valuable goods discarded by others.

I love it all. I love *you*, for what you do not love, what you throw away. There's a sad paradox in that. I love you for your lack of love for what I love.

I have to say that my pride in this label collection, and my determination to keep it up, are balanced by my annoyance with it and my sporadic resolve to give it up, even to throw it out. By now it has swollen to such proportions that no one would ever have the time or interest to explore it all. I have seen people—friends—visibly repelled by it, as if it were a monstrosity, a huge boil or wen, gruesomely fascinating but still disgusting. I wonder if those guys who save string on enormous balls have a similar experience, or the hoarders who save every newspaper, every piece of junk mail, every oily rag and unused bus transfer. I myself find it terribly unwieldy. Individual binders seem always to be on the verge of bursting, forcing me to decide how to split the contents into two binders. Division does not come easy to a man who craves wholeness.

Early on, I picked out of the trash at the Yale library six identical blue binders that had previously held lists of books and articles put on reserve for various courses. At a certain point the whole collection was contained in these binders. One was labeled "Canned Food," another "Jar Food," and so on. Now the collection comprises eighty-three binders of flat labels and fifty-one boxes of miscellaneous boxes, not including the cereal boxes, which are in such an array of containers that it is difficult to count. Those original six blue binders now house "Butter, Oil, Margarine," "Fish, Meat," "Tobacco," "Spirits," "Bags," and "Fresh Food—Vegetables." Actually, "Fish, Meat" has just split into "Fish" and "Meat," the latter going into a new binder, but I have not yet rewritten the label. Their bindings were weak when I recovered them from the trash, and now they are worse. "Maintenance" is a perennial problem; infrastructure decays. Having ages.

It did not take long to realize that the earliest pages, which I had punched for the three-ring binders, were tearing. So I started placing the pages in plastic sheet protectors, but soon I discovered that these were not all of archival quality. Some get brittle or yellow or stick together. They tear, they crease, they

feel . . . like plastic. Was that ever what I wanted? Where are the polyurethanes of yesteryear? In youth, we imagine that materials will last forever. In middle age, we experience the first tears and fraying at the edges. Colors go flat, edges fritter, and a whiff of acid hits the nose. Some collected things will obviously endure for decades, while others seem just minutes from the grave. Ephemera happens.

Another, even more oppressive problem is the taxonomical one. A label for canned peas clearly belongs in the remaining "Canned Food" binder (from which I long ago extracted canned soup, canned fish, canned olives, canned tomatoes, canned beverages). And a label for fresh peas clearly belongs in "Fresh Food—Vegetables" (minus "Mushrooms" and "Fresh Tomatoes"). Frozen peas goes in "Frozen Food." But where do dried peas go, or wasabi peas, a delicious snack? When I was a kid, I did not like peas in any form, and now I find myself regularly having to digest them twice, inside and out. I face this problem—the labeling of labels—each time I process new acquisitions. Does honey go in "Sweets" or "Basic Ingredients"? Are pretzels still in "Snack foods" (exclusive of "Potato Chips"), or should they go in a new, dedicated "Pretzels" binder? What about bread sticks? In "Crackers" or in "Baked Goods"? Aren't they pretzel-like? Sometimes, it's hard to recall the current system across the several months in between sorting sessions, and I have no Dewey Decimal System, no Excel database. The world offers food in sloppy profusion to the middle-class American consumer, and I know well how far short of Linnaeus I fall in arranging the genera and species of groceries.

Then, too, even within a category I fuss over the order. I like to have similar products together in the same sheet protector or opposite one another: all blueberry labels together, earlier and later variations of the South Alder Farms Bleuets label next to each other. But that means remembering just where particular blueberry labels are, among the various berries, and shifting la-

bels around to insert a new one into the collection. Sometimes I let the pages pile up for half a year or more before I finally face the task of integrating them. Even then, at the end of a long evening, I will have a pile of problem labels that require special handling. Some have remained in the problem pile for years—my baggage.

The bigger the collection gets, the harder it is to keep. The bigger the collection gets, the more completely it represents me and my history, and the more I feel oppressed by it. The bigger the collection gets, the more extraordinary and "valuable" it is, and the more I mourn the thousands of hours spent assembling it. In the hole and on the peak, I love this collection and hate it, and I keep it because it expresses me, though rudely. It is a poor collection wishing it were rich. It is a celebration of material culture wrapped around a contempt for material culture. It is a burgeoning collection full of emptiness. It is a collection of nothing. That is my title, and I am its lord, its consumer and author and subject and victim.

I wish I did not have to express (repeatedly, compulsively) such ambivalence about this and my other collections. Most collectors celebrate their collections, and celebrate themselves by means of their collections, no matter what they collect. Most books about collecting ring joyous bells. A shelf full of glass eyeballs or Betty Page figurines or Brownie Instamatics becomes a treasure house, the culmination of a romantic quest. No doubt the collector of dictators' signatures or barbed wire samples or prison uniforms will have suffered during the years of accumulation, and perhaps the sacrifice required to obtain a prized possession has exacerbated that suffering, but the collection finally stands purified of that history. Out of the restless activity of life, collecting creates a timeless array, the wondrous world of bobbleheads or whatever. Why can I not make that leap? Why does my collection, this one above all the others, seem so laced with misery?

My collection is a picture of middle-aged me. To collect is

to predicate middle age. The novice collector has that gnawing desire but only a few paltry things, then more and more as the years go by. Still, there are spouses and children and employers to diffuse the energy. The desire persists, like a low-pressure zone, drawing moisture, and the rate of acquisition gradually builds. Collecting never satisfies that desire but rides over it, like the wind on waves, lifting whitecaps and small craft warnings. At a certain point it becomes clear that a hurricane is blowing. The storm strikes in middle age. At that point, there is an electrically charged mass of collected material, enough to shock the noncollector, and the lightning is ferocious. Many will drop their material comforts, their pets, even their children at this point and run for cover. The true collector will see the storm as a fine opportunity, a magnetic moment, and draw the storm's energy into the vortex, as an oak tree draws lightning into its roots. Cyclonic, the midcareer collector becomes a solitary force of nature, with familiar things all whirling in the air.

Or something like that. Once the rest of life, the normal challenges like getting an education, finding a mate, establishing a career, planting a garden and an IRA and some children, has been accomplished, collecting takes center stage. A collector's passion, in its infancy, can be almost embarrassing, when you have only, say, five shot glasses, six pieces of antique lace, or four Roman coins. Best not to show anyone then, certainly not the kids, or to make the claim that you are a collector. In any case, you have more important things to do, like trying to stay compatible with your wife and in love with your job, or is it the other way around? Later on, though, once those important things have become routine, your personal passion becomes both more obvious and more insistent, and now with your spindly legs and slack neck you look and feel a little ridiculous.

Eight years ago I began seeing a therapist and learning something about my own pathology, my wounds, my imperfect healing, my sharp edges dangerous to others. My joy, unfortunately,

felt like sadness, and my good fortune like dust, and it took a while to begin clearing out the lingering guilt and shame (like heaps of old newspapers) to get down to the solid furniture of my life. I had hoarded so much of this bad feeling that it took three years of therapy before I even mentioned collecting to my therapist. Two years later I found out that she is also a prodigious collector and is married to an even more prodigious collector. Freud was a collector too. He looked, as my therapist does, for valuable artifacts from the past, expressive stuff—a material extension of the work they do professionally. Whereas I take discarded remnants from the present—from the trash—and treat them with the same care, if not the same pride, as I do my own elimination. A psychosexual tangle surrounds this collection (and me), which I have at last taken time to sort out. Call it my self-love, at once ironic and excessive, unique and commonplace, open-ended and delimiting, sweet and smelly. I make a good patient, which is a little sad.

I can look at my label collection as a first-class achievement or I can look at it as a river of pain. I can view the collection as a marvelous fantasy or as a mental block, breakthrough or disaster. I can cling to it and also wish to throw it the hell out. I deserve much more than a mountain of aging labels, and at the same time I am enormously blessed to have even that.

Since my divorce I have been in several relationships, lasting from a few months to three years, and I have met or dated a number of women in the intervals. Always it has been a puzzle when to bring up the fact that I am a collector, and more recently when to bring up the often disconcerting fact that I have been writing about it. Middle-aged women are especially on guard against being "collected" (of course, there *are* men who do such things), and the prospect of showing up eventually in a catalog holds no appeal at all. (John Fowles wrote an especially creepy novel called *The Collector*, about a butterfly collector who kidnapped a woman so that he could feel what it would be like to

have a perfect, live specimen of beauty, pinned, as it were, to his bed. This is one book about collecting I have *not* collected.) To keep my collecting concealed, as I often did when dating, makes the eventual disclosure all the more loaded, yet to mention it at once necessitates a lot of explaining at a time when it may not be worth it. The oddity and magnitude of my collection suddenly throw everything else about me out of proportion. Eyes widen or roll, some of the women bolt, and I realize I am on the verge of becoming this week's *Sex and the City* anecdote, the guy who plucked an empty Orthogynol box out of the wastebasket after the tube's contents went somewhere else, along with me. Partly to stave off this laughable rendition, I have cultivated other ways of thinking about the collection that give it an aspect of artistic or academic seriousness.

On a personal level, the collection speaks of love and its loss, self-worth and self-hatred, and the awkwardness of my own connection to other people. On an impersonal level, it speaks of the riches and excesses of an era of late twentieth-century life. It testifies to the remarkable liberty of a middle-class academic to satisfy his hungers in diverse, luxurious, laughably mundane, and occasionally exotic ways, and at the same time it begs the question of why that liberty was exercised to these ends. What was so good about Wolfgang Puck "Signature" soup, Soho cream soda, or Le Saint Aubin brie? My conspicuous consumption is on record, now more conspicuously than ever, and it is testimony to a late-century polymorphism.

I can spiel on about how the white paper, to which the labels are affixed, works like the white walls of a modern art museum, so that each piece seems an "iteration" of Jasper Johns or Warhol. These are iconic prints, many made to a high standard of craft, and they operate in a complex, coded system, sending thousands of messages and asking the viewer to buy, just like many works of art. Think of those Dutch paintings, showing a table of fruit and flowers, with perhaps a skinned rabbit hanging on the

wall behind. Those paintings send a signal about the purchasing power of the burghers who owned them. My labels too reflect the Horn of Plenty, and they too have rarity and elegance. I could and actually did buy a Reggie bar.

I talk about how the collection helps us see the world anew and recognize rarity and richness in the things of common life. Though once they were common and cheap, some of my labels would be as difficult to replace as a Cimabue altarpiece. Who else out there owns an authentic early 1980s Glamour Puss Fish and Liver Flavor canned cat food label? (Yes, fish and liver.) The manufacturer no longer exists. Mine might be the sole surviving example of this quite ordinary, unusual label, unique in the world.

Here my date might perk up. "How much are they worth?" she might wonder, or even ask. We might have met through match. com, where there is no line on the profile page (an oversight?) to record the metric tonnage of one's accumulations. I might have listed *collecting* in a "hobbies" paragraph. "That could be interesting," she might have thought, or "cute," picturing a decorous shelf of antique bird decoys or Depression glass or, hey, rare editions of the Kama Sutra. Still, the subject will not be broached until it is time to wonder whether we dare order refills for our "grande" cappuccinos.

Then, it comes: "So, you collect?" Perhaps it's a real question. She may be wondering if I was instead the one who mentioned hang gliding as a hobby.

Or I offer, "No, I collect," perhaps to diffuse the awkwardness of her having asked how I got into hang gliding.

"Oh," she says, before gulping the last of her cappuccino. "I have a niece who collects key rings. She's ten."

In such a moment, I dearly want my collecting to be a selling point, like a mountain cabin ("There's only a wood stove, but I finally installed an indoor toilet and Jacuzzi last year") or Goya prints ("But I'm thinking of selling them, because they're too expensive to insure"). Instead, I have to anticipate her coming to terms with thirty years of Cheerios.

"Ohmigod," she pants, her eyes turning to liquid pools, "you have the original Honey Nut. They are *so* delicious. And yes, I'll have another grande. (*Singing*) Can't get enough of that Sugar Crisp, Sugar Crisp, Sugar Crisp. . . ." This dialogue, of course, never takes place.

I LOOK CLOSELY these days at the worlds of the people in my life, for example, the house of a woman I dated for a while. Her perfectly proportioned bungalow is fitted with just the number of carefully accumulated and displayed objects the eye would wish to see, not one more. She has one true collection, souvenir "floater pens," the sort in which some tiny part moves in a fluid medium under clear plastic on the upper part of the pen. Her entire collection fits neatly on one shelf in a labeled rack. The pens speak to her of her travels. They tell of one small segment of the kitsch industry (she knows the name of the principal manufacturers), and they relate perfectly to her career as a writer of moving pictures. There is, in fact, a "society" of floater pen collectors, and a newsletter. She knows just where to go on eBay. Elsewhere in her house there are fine things, things worth having, and nowhere a mass of ambivalence. I look at her world, as

defined by these objects, and wish that it were my world, a world of insider privilege. Of course I would not fit into that world and fear that I might disrupt it, but my desire goes there as easily as to any utopia. But she had had enough of me after a few months. Of cheery O's enough.

I suspect that collecting is, for most, a way of retreating from relationship rather than engaging, like the turn to a woodshop in the basement or a late-night blog session. Bird-watching at dawn is often a way of bolting the door behind you, and so is

the pursuit of still another kachina doll for the collection. I have had relationships in which women pursued me into my obsession, but eventually they came to resent that bolt. With one woman, I created a new collection, the "kitchen collection," which was initially just a wall full of the PLUs ("price look ups") you find on fruit. At a certain point, I put up two pieces of black paper in unglazed frames, and we affixed those little labels, as well as other bits of ephemera—junk mail, odds and ends—which we arranged in haphazard compositions as they came along. Eventually, though, I was the one who was putting all the effort into this collection, and eventually she was the one with the Ryder truck.

The great majority of divorces continue to happen in the early years. The increase in the rate of divorce in the middle years just keeps pace with the increase across the board. However, middle-aged divorces involve more . . . everything: headlines, repercussions, furniture; complicated photo albums, well-paid attorneys, heartbroken innocents. Mine had more grocery by-products than most. With one child wailing on my lap, and the other drenching the kitchen table with tears, I knew, at least, at last, that I had awakened to something deep at the bottom of why I would happen to have a book of water, containing at least one label from each of the following brands:

Aberfoyle	Amish	Artes
Absopure	Apollinaris	À Santé
Acquachiara	Appalachian	Avra
Adirondack	Aqua D'Or	Aziza
Aga	Aquafina	Badoit
Alaska Glacier Cap	Aqua-Pura	Bailley
Albertsons's A+	AquaVibe	Ballygowan
Alhambra	Aquarel	Bartlett
American Faire	Arctic Blue	Bassin de Vichy Saint-
American Star	Arrowhead	Yore

Bernina
Best Choice
Big Bear Mountain
Big Sur
Bisleri
Blú Italy
BonAqua
Boulder
Brecon Carreg
Brightwater Ridge
Bronwater Cristaline
Butterfly Spring
Buxton
Buxton Spring
Calistoga
Campsie Spring
Canada Dry
Canadian Clear Springs
CAP10
Cascadia
Castle Rock
Center
Chippewa Spring
Chumash Casino
Ciel
Claudia
Clearly Canadian
Cloverfield
Coastal Fog
Contrex
Contrexéville
Cool Springs
Coralba
Corner Bakery
Cotton Club
Country Meat Market

Cowboy Trail
Cristal
Crystal Clear
Crystal Geyser
Crystal Lake
Crystal Mist
Crystal Springs
Culligan
Daily Grind
Dannon
D'Aquino
Dasani
Deep Riverrock
Deer Park
Déja Blue
De Los Angeles
Delta
Déluge
Deveron Valley Sports
Earth$_2$O
Eau de Cristaline
Egeria
Ein Gedi
Electropura
Esker
Essentia
Eternal
Ethos
Euphoria
Evian
Fabia
Fat Free H$_2$O
Fern Brook
Ferrarelle
Fiji
Fontana

Faculty Club
Fonte Gaudianello di
 Monticchio
Fonte Guizza
Fontepatri
Fonte Tavina
Fonti di Ramiola
Foster Farms
464 English Natural
Four Seasons Biltmore
Fry's
Galvanina
Gaverina
Gelson's Finest
Gerolsteiner
Getty
Glaceau
Glacier Clear
Glacier Valley
Gold Emblem CVS
Goldwater's
Goleta Coffee Co.
Grand Barbier
Grove
Gugar
Hansen's
Harilds Kildevand
Harrogate Spa
Hawaiian Springs
Hawaii Water
Hearst Castle
Heaven and Earth
Hesburger
Highland Spring
Hydro Dog
Ice Age

Iceland Pure
Iceland Spring
Ice Mountain
Iris
Isopure
Ivi
Jamnica
Jarritos
Juwel
Kalil Kino
Kirkland Signature
Kroger
La Croix
Lady Lee
Lambeau Field
La Vie
Las Vegas Hilton
Le Bleu
Le Nature's
Lora di Recoaro
Loutraki
Macy's
Madonna Suite
Manitou
Marks & Spencer
Melwood Springs
Member's Mark
Menehune
Meraner
Mesti
Metro
Mineral Springs
Monadnock
Montclair
Mountain Brook
Mountain Forest

Mountain Sweet
Mountain Valley Spring
Naked
Nascar
National Cathedral
 School
Natural Café
Natural Spring Water
Naturally Tasmanian
Naya
Nestlé
Neviot
Niagara
Nicolet
Nirvana
Nongfu Spring
Nor Cal
Norda
North Country
Not a Hint
O'Brien's
Oregon Pacific
Oregon Rain
Osmopura
Ozarka
Palomar Mountain
Panna
Pavilions
Penta
Perla
Perrier
Pineta
Poland Spring
Polar
Pozzillo
Pracastello

President's Choice
Prestige
Price Wise
Propel
Publix
Pure American
Pure Matilija
Pure Water, Bermuda's
 Premium
Purely Scottish
Quaker H$_2$Oh!
Quality Candy
Ralph's
Ramlösa
Rayne
Red Diamond
Refreshe
Relay for Life
Robust
Rocwell
Römer
Romy
Safeway Select
Sahara Burst
Sainsbury's Caledonian
Saint Diéry
Samco
Sam's Choice
S. Andrea
San Benedetto
S. Bernardo
San Luis Paints
S. Pellegrino
Santa Barbara Water Co.
Saratoga
Sbarro

Schweppes

Sequana

Shan Quan Shui

Shurfine

Sierra Springs

Silver Springs

Smart Water

Snap₂O

Solan de Cabras

Solé

Souplantation

Source Montclar

Southern Home

Sovrana

Spa

Spar

Spådel

Sparkletts

Springfield

St. Michael

St. Ronan's Spring

Stater Bros.

Stauna

Strathmore

Stretton Hills

Subway

Tipperary

To Go

Trader Joe's

Trinity

True

Tuborg

Türkmensu

USA

Valvert

Vasa

Venus

Vera

Veryfine Balsams Spring

Vintage

Virgin Atlantic

Vitality Springs

Vitamin Water

Vittel

Viva

Vivo

Volvic

Vons

Wabeno

Wahaha

Waiwera

Washington Duke Inn
 & Golf Club

Westward-Ho

Whistler

Wildberry Geyser

World Black Belt

Yosemite Waters

Yun Nan Shan Quan

Zagori

Zaro's

Zephyrhills

I needed a list here, as collectors always need lists and masses of things, all neatly contained. I needed a buffer from that wrenching scene of my children in tears, and me in tears before them— flooded with grief, even now. We have our sources, our natural springs, of pain, and our ways of going on. We wash our eyes, flush the guilt, but the erosive trace remains in the rock.

Once the garage of middle age is packed up and then unpacked in a wishful future, with its own capacious garage, the day goes on, only now there is less time to get it right the next time. What goes where is a question that keeps arising in dating and mating and making new relationships. You want to find

vertical stripes to conceal your bulky obsessions, those binders of sardines and the funny bottles of potions to comb the gray out of your beard. One does not want to bulge at the canned-seafood-label line, and even having too many books of modern poetry, as I do, might seem worth concealment—or too many recordings of Schubert songs, or even some few pieces of once-polished scrap metal from one's adolescence. Such things require too many chapters of self-explanation, at just the point when neither of you particularly wants any prose at all. Periodically, I took stock of what was most presentable about my collecting, to find at least an entry point to what was surely going to seem a little overwhelming.

So, because I would like to be welcome, welcome reader, I might begin by showing you my collection of envelope linings. It seems that many people fear that if they send a check or some other document through the mail, it will surely be noticed by a nosy postal carrier or a larcenous neighbor, and so an assortment of envelopes is available, lined with some dense pattern to prevent anyone holding it up to the sun and reading the contents. Those are envelope linings, and I have a very large binder containing two-inch-by-three-inch cuts from such envelopes. The binder is neatly maintained, each page containing a grid of five rows and five columns of envelope linings. After the first few pages, which came in random order, I organized the pages according to category: stripes, florals, hatch-marks, trademarks, solids, airmail specials, and so on. The effect now is like a sample book, demonstrating the wide array of possible envelope linings, and it is colorful and elegant. Everyone who sees it says, "I never imagined there were so many different kinds." There are currently over eight hundred distinct envelope linings in the collection. No one covets what I have (I have found *no* Web site for envelope linings), but when people look at this collection I know that I have something rare and extraordinary, even eye-opening. What I have in this binder brings forward the thing

that makes surreptitious reading impossible, that thwarts the stealing of secrets, many times over.

I collect my metaphors. I figure myself in these nothings. A multiplicity of envelope fragments translates into an album of intimacies not established, dialogues not worked out, stunted love. What might I have done with the hours, usually at night, devoted to cutting and pasting these bits? I want you to pity me for my wasted nights. I want you to respect me for my committed hours of gluing, my sticky fingers deftly handling these delicate tissues. I want you to love me for all I am (all I have). I want you to see that I have pasted myself in, harnessed something of my energies, secured something of myself in a grid, however bizarre. Please.

❖

{ V }

NOTHING SPECIAL

Down, down, down, near the lowlier depths, just above sludge, my collections twist and turn in eddies of insignificance, and I am the catfish. At various times, I have saved the worn strips of masking tape that had been on a gymnasium floor for several weeks, the penny tracts sold in church lobbies, a photograph of someone's damaged artwork made for insurance claim purposes, and tea bag tags. The verge of zero has often been the vicinity of my drilling: movie ticket stubs, California cheese emblems (though I prefer Wisconsin), stickers boasting "Made in the USA," "...in Hong Kong," "...in Taiwan," "...in Guatemala," and on and on. As my taste plummeted, I realized how much I was able to enjoy the lessness of dross.

Like most collectors, I like finding good matches of object and vessel. This is perhaps a metaphor of finding home or mate. Collected objects alone make a mess, and containers unfilled seem unfulfilled, but they marry one another's needs. Even if I

do noodle in the muck, I'm finding the right form for my collections in this book, in my life—and yours.

A BOX MADE FOR MICROSCOPE SLIDES became home for a clutch of rusty skeleton keys found in the woods. Once I had those unlockers successfully lodged, I held onto every key I could find, several hundred, and they wound up in another, larger box—keys to nothing, now locked in a wooden chest.

BUSINESS CARDS come readily to hand, and I have about six thousand, all tokens of connection, that I have idly picked up. In this category, I am a minor leaguer. There is a fellow out there named LeRoy Gensemer who has more than six hundred thousand business cards. The Web site of the International Business Card Collectors Society provides links or addresses for dozens of other collectors, many of whom have at least ten thousand cards, if not a hundred thousand. There is a Business Card Museum in Erdenheim, Pennsylvania, which began in 1995 with Ken Erdman's collection of a hundred and fifty-six thousand and now has over three hundred thousand. Theirs are the epic collections, while mine is hardly a novelette.

I enjoy the uniformity of this collection, the standard-sized cards packed together in a block, capturing the names of widely scattered people and businesses. For each, I have made my reach, a meaningless handshake. They constitute a community of which I am a part (my own new "Professor/Collector" card is among them), but a community united only by this cookie-cutter means of self-identification. In a way, these cards have been commandeered to declare my lack of cooperation with their enterprise, since the moment of seizure misses fire. When I take a card from a business, the owner hopes I might become a customer, and once in a great while I do shuffle through the randomly arranged collection in search of a forgotten name or address for

the purpose of commerce, but usually the cards are mere units in a series. Call it artwork, call it folly, those businesses should write off the expense of the card taken, as a charitable contribution to nothing much, the art of me.

POSTCARDS TOO are mostly uniform in size. Together in four library boxes, several thousand of them look like a card catalog. They point to a crisscrossing dialogue across many years. Some of these cards were sent to me, but many were sent to others and then reclaimed by me from the trash, or they were never sent at all. A large collection of postcards contains the world, or represents the wide world and its masterpieces, more explicitly than any other collection. They have truly "girdled the earth," to use Puck's phrase, with images of what you can see only if you go abroad, albeit hand-retouched, half-toned, now chemically degraded images of anonymous commercial photographers as handled by the not-especially-cautious postal services. This collection traverses the ever-variable distance from you-can't-go-home-again. The rarest sights, Apollo Belvederes, ex–vice presidents, and humblest palm-tree sunsets come together on uniform pieces of cardboard, the cheapest, and most heavily graffitoed, of museums.

ONCE OR TWICE A YEAR, my parents will visit me, as will, less often, my brothers. More often, I go to them. Oddly, I seem easier to transport. Their vast television screens, minivans and maxi-SUVs, hot tubs and wet bars, purple iMac majesty and waves of amber children, by far outweigh the odd gross of saltines boxes I have and hold. Then, too, I like raiding their pantries, hunting unusual butter boxes or Piggly Wiggly water. The regional dispersion of my family contributes to the diversity of my collections. For a while, we three boys had scattered about as far from Ohio and each other as we could go without leaving the contigu-

ous forty-eight, Peter to Alabama, Andy to Massachusetts, and I to California. (Cindy remains in Canton, but mentally more expatriate than us all.) We talk with some regularity on the telephone, listening not so much for the content of the conversations—typically performances of things being "fine"—as for involuntary sounds of cracking.

As fathers, we devote a lot of attention to our children, and we collect anecdotes of their sublimity. We imbibe their freedom, which might come in the form of ludicrously striped socks, or calling their second grade teacher a "loser," or doing a Pilobolus on the high diving board before plunging, then return to our grim duty the next day with a slight hangover. Lately, I have been collecting my parents too, meaning their distinctive forms of speech, family-specific terms like "mickeystocker," "wrinch," "skizzers," and "nixnooks." I put them in a book, a glossary of clan code. Collecting can be a defense against dissolution.

Meanwhile, I continue to enlarge a collection of four hundred or so expired credit cards and library cards and health insurance cards, as well as numerous pseudocards, plastic come-ons mailed out to coax you into opening your junk mail and reading the sales pitch for an actual card. Credit capitalism with raising names from the very surface of plastic, if only John Doe.

A FLAT BOX holds miscellaneous pins, buttons, and badges, their imprints touting political candidates and causes, self-help affirmations, commercial wares, and nothing in particular: "Ban the Krugerrand," "History Is Everything," "WIN," "Reading Is a Magic Trip," "Washington Is a Capital City," "Black People Support the Miners," "Birch Bayh '76," "Boycott Gallo," "Support Nancy's China Policy," "Save the Wilcox Property," "A Constant Concern," "Stamp Out Idiocracy," "Jerome Tuccille for Governor of N.Y.," "Mostly Mozart 1981," "Udall for President," "Dodgers Beat Yankees 4 Games to 2," "Commander Salamander," "Joe," Out," "I Am Loved," "MORE," and more.

I ALSO HAVE playing cards, but only the jokers—the fool, worth nothing except when he beats all—and a few dozen aces of spades.

Pogs, patches, stickers, metal tokens, washable tattoos.

Cellophane-wrapped coupons and recipes, pocket calendars, Metro cards.

Matchboxes and matchbooks. "Tamper-Evident Seal" stickers.

A wide variety of things, you see, but not everything, because a lot of it you have, and the rest we've thrown away, and this stuff is small.

THERE ARE HYPERBOLIC COLLECTORS in just about every category. As with the business cards, there are folk out there actively pursuing old Visa cards, store plates, Social Security cards (not to mention the numbers), and library cards. Thousands, maybe tens of thousands, of people collect postcards, each hungering for rare views of Mount Rushmore or Fort Lauderdale or Buenos Aires, naughty cartoons, generic images of dull motels (the duller and more generic the better), paintings in the Louvre, Le Havre, MOMA, and MOCA, Venice and Venice Beach, and artifacts from the Museums of Natural History and Sex and Sports and Folk Art and Tolerance and Technology and Jurassic Technology, as well as promotional cards for openings, screenings, recitals, prostitutes, healers, and someone's new book.

Political button collectors have published price guides (Mo Udall does not command a very high price, but more than the libertarian Jerome Tuccille), and some of the Web sites of these collectors proclaim that collecting this stuff is doing the work of an historian. The fact that I did not even know about the fanatical collectors in these areas until I just now did Web searches

suggests that my collecting is not in the same category as these others'. A recent (marvelous!) book about random, impulse-driven collecting names my fanaticism well, *In Flagrante Collecto*, because the collections always read, at minimum, as admissible evidence.

Collectors of one sort typically have little respect for collectors of other sorts—those others are *all* guiltier. Stamps seem doubtful to numismatists, coins bizarre to philatelists, and airsickness bags repulsive to anyone other than airsickness bag collectors, of which there are a few, and they undoubtedly scoff at hoarders of Happy Meal toys, who look askance at the prigs who pay thousands for Whistler prints. Yet even if we don't cotton to each other's choices, collectors recognize kinship. We are strange to one another, but a sniff tells us we belong to the same species, and we hunt with like instincts. Collectors all know the joyful and terrifying moment of glimpsing a new and wonderful object for the collection. Eyes lock on the prey, and the breathing deepens. Instantly, we size up the whole context in which the object appears and assess the hazards. We do that to make the crucial calculation of how to acquire, all other questions now peripheral. There will always be a narrative of the object's seizure, like the big game hunter's tales, and even if it is only "I picked it out of a gutter in Goleta" there remains that memory of the first glimpse, the pounce, and transport home. Finding something feels like a miracle, confirmation that the world is providential.

Granted, the tale of how I snagged an empty box of (to me, inedible) Reese's Peanut Butter Sweet & Crunchy Corn Puffs (General Mills) with the Yu Gi-Oh! Action Medallion ("Free Inside") has limited resonance with most people. Almost always the environment of my capture is a lowly one: Safeway, Long's Drugs, a five-and-dime or dollar store, or, as often, a back alley, a dumpster, blowing in the wind, down by the banks, and anywhere my whistle goes. I have pulled my car to the side of a road to walk back a hundred yards and pluck an eye-catching Wheatables box

from the weeds. My science has been to accelerate these subparticular ephemerals in order to glimpse the quirks and quiddities of a minimal attachment to the world of grave objects. Such has been my choosing, and so I have subdefined what's "choice"-ish, what a James Joyce might call nadathing, less than the pinpoint eye might encompass, even on a cloudy night. Figments of fragment.

I HAVE NOT entered into the larger economy of collecting. The International Business Card Collectors Society, for example, declares on its home page: "Welcome, fellow business card collectors and those who are interested in becoming a part of this fascinating hobby. If you are a collector who just stumbled onto our site, then you are probably thrilled to discover that YES, there really ARE other folks who collect business cards! There are more of us than you ever imagined. The Internet has provided a wonderful opportunity for us to connect with each other, share ideas, exchange cards, and benefit from the combined knowledge of many." To me, this is exactly like the Chamber of Commerce or Elks Lodge meetings I have never attended. I'm just not part of that community, and yet, it so happens, I am.

As tokens of a moment of collecting, if nothing else, my marginal collections (add "Hello, I am _____" stickers and the clear plastic reminders of when your next oil change is due) have nostalgic value, but little else. In among the small collections are smaller ones ("If you have more than one, it's a collection," someone said), and in between those comes the miscellany, and in the miscellany comes the stray whatsit, dingus deluxe. And among them all comes my claw. I once delivered a paper called "Miscellaneous" at an academic conference, in which I spoke for the things that stand beyond classification, the extracategorical *et ceteralia*. My collections open at just the point where the dam spills over: bric-a-brac, froth, rubbish, and dreck. It's a case of ephemerrhea. Enough said?

I like these knee-jerk collections (or maybe I should call them subcollectings or rootings about), but I pass over them because they are essentially just pools of accumulated findings. I don't actively seek any of that stuff, much less buy it. If I did, I'd have cause for worry because then I'd be a classic collector, which I do not want to be. Instead I would say, with Peter Handke's character Kaspar, "I want to be a person like somebody else was once." Wasn't there a time when I might have been not a collector, which seems to me an automaton role, but a person? There are times when I achieve that goal and behave personally—talk and listen, make and remake, move/breathe/sing with love, play with my children, check my e-mail (never a postcard there), hike the Santa Barbara mountains, where bottle caps or gum wrappers will not likely be—and then I do not need to be a collector. But I still feel that urge to pick up any business card I happen to see, to pearl-dive someone's envelope out of the trash, to hoard and box up a selection of the litter along my pathway through life. It is a gentle compulsion, stronger than a habit, and fortunately not quite an obsession.

I know there are moments when I am controlled by collecting, but it rarely impairs my normal functioning. I'm not like those Collyer brothers, Langley and Homer, who in 1947 were literally crushed by their own hoarded mass of things (103 tons). I hold aside the possibility that collecting might have interfered with my relationships, but then it might also have improved them. Collecting is something I am always doing, like tending to my appetites, maneuvering myself through the thicket of social customs, seeking and maintaining a nest. Its constructive adjuncts include collecting books and other materials that might (or might not) turn into valuable sources for my teaching and scholarly work, books about O'Neill, melodrama, avant-garde performance, mesmerism, spiritualism, magic, antique science, anything to do with 1850–1851 in England or Scotland or 1895 in

London, Wallace Shawn, pulp fiction, Harriet Beecher Stowe, memory, speaking in tongues, Nicholson Baker, Schumann, Isaac Levitan, Chekhov, Andy Goldsworthy, Will Eno, early photography, Roland Barthes, me, and collecting.

I also collect music, including a wide range of scores for me to play (amateurishly) on the piano and even some old sheet music, the one sort of "collectible" I will spend money on, though not much, specifically because I can then use it, or discordantly try. It is axiomatic that use will drive *down* the value of any item. Perhaps I buy a useful collectible in the knowledge that my use will drive its value to nothing (it doesn't take long with sheet music), at which point it will fit my collecting criterion.

I can see the clear correlation between the books and music I acquire and my self-improvement and pleasure. My seven or eight thousand books, my one or two thousand pieces of sheet music, my couple thousand LPs and CDs don't, in aggregate, seem like collections to me, though in the sense that I approach them with the attitude of wishing to attain some comprehensive goals they are more like collections than what I call collections. I'd love to own all the books written by the Baron von Reichenbach about his experiments in the 1840s and 1850s with the "odylic force," all the poems of Berryman and Ashbery, all the old paperbacks of *Ripley's Believe It or Not*. I want to own scores for all of Bach's keyboard music and recordings of every one of his cantatas, as well as the complete Harry Partch discography, Schubert's lieder, and never enough Frank Sinatra. For each of these things I might have, there is or was an activity in my life that would be enhanced or enabled as a result of my owning it. The same cannot be said for business cards or old keys, and even less can be said for the gobs and gobs of hoo-hah in a tin, not polished, not labeled, not dated or alphabetized or cataloged, utterly mundane. Those things, I just collect in the primary gesture of collecting. A collector's life has a lot to do with pointless keeping.

I HAVE A collection of trademarks—not every one, but every one I could find to fit into the container I had found for them. One day while in graduate school, a bulk trash day in New Haven, when the locals left heaps of their unwanted things on the curbside for pickup, I came upon a discarded address book, well, not a book exactly. It's a pre-Rolodex gadget such as I haven't seen in use for a quarter of a century: a brown metal box, about three inches by six inches by an inch, with a knob on the top. You slide this knob along a groove, alongside which is the alphabet. Stop the knob at "P," push the metal lever at the bottom, and up pops the lid, displaying the page marked "P." There you would write in the names and addresses and telephone numbers of P-people. Close the lid and slide the knob to "E." Voila! All the E-people. I found this handy item in someone's trash and quickly saw its use, which was not to hold the very few names and addresses I needed at the time. (I have always kept those on one folded, occasionally reinscribed page in my wallet.) Instead, I saw it as an organizer of tiny emblems, an alphabetical incorporated world. I started clipping the trademarks from magazine ads or product labels and inserting them in the proper alphabetical position.

The instant I began this process I saw how difficult and unpleasant it would be, how long it would take to fill even this one address-finding device. Arranging these minute pieces of paper in tight order and gluing them in was maddening, and not having enough to fill the difficult pages (especially Y–Z) was frustrating. Soon I found myself tearing through magazines in other people's apartments, searching for more Fs or Ns, and surreptitiously snipping them out. I hadn't counted on the thickness of the trademarks posing a problem, but by the end the gadget bulged, and now I need a dog collar to bind it closed, lest it bark at me. Eventually I completed that collection, then quit. That way laid madness.

I ALSO HAVE a slim volume of found words that are (or were, at the time I found them) not words at all, just marketing concoc-

tions or neolinguistic extravagances. These words are all clipped from some printed source. Here is an alphabetical sampling, in pairs:

alphakey arizonaguide	*jarrow jerzees*	*slan starz*
basketwrap battenkill	*khakiware kutrimmer*	*traumarama twinkie*
colorite catling	*laidlaw lotops*	*ultimatte urestone*
displex dratch	*microsoft modemag*	*varn vacuumatic*
eenie ecover	*nimlok nublend*	*waveform woolmark*
funkexotic flintability	*ofoto obscurism*	*xhilaration xtent*
gougenheim gue	*palding printloid*	*yourselfer yurman*
hpnotiq hedstrom	*quallofil quicktionary*	*zip-clip zumanity*
infusino interphones	*racetech risdon*	

These are the rare words, the hopefully floated, caught-at-a-glance, mostly expired words, with a few that stuck. I have a few hundred of them in a little rice paper book.

MY SCRAPBOOKS hold all that clung to me during my crossing through the latter part of the twentieth century. My wake undoubtedly crossed yours many times, and I think you might see with a certain jolt of recognition the Cracker Jack "Fun Badge" or the Clinomint Stain Test ("Hold this test card up to your smile") or the District of Columbia TOW sticker or the Timex clock face or the tag inscribed, "This garment is delicate, please remove jewelry before you try it on." American Tourister used to include the keys to your new suitcase in a small envelope with a demurely smiling key-shaped bellhop figure, and I have that envelope. But maybe you never bought American Tourister. (I know I never did.) Well then, maybe you've gone to a Chinese restaurant or two. And maybe the wrapper for your chopsticks carried a set of diagrams showing the proper use of the sticks. I have quite a few of those.

I have in my scrapbooks cigar bands picked off the street (with probably a flake or two of Cuban tobacco clinging to them),

luggage tags, place cards, and bookmarks. A PSA Airlines ticket envelope shows three stewardesses clad in mod orange 1970s uniforms. A yellow door card tells me, "Your water company service man has been here." An aggressive plastic tag button-holes me with this declaration: "Try Me, I'm a Red Flame Seedless." I have the entire check-out sleeve from the Naropa Institute Library for Tom Stoppard's *Rosencrantz and Guildenstern are Dead*, complete with Date Due slip and sign-out card, all blank. It's a good play but apparently not especially interesting to Zen Buddhists. A little pamphlet from the store Britches of George-town instructs me in how to tie a bow tie, should I ever want to wear one. A bold gold star declares that the once-attached item was one of the "Top 99 Products Made in the USA" (according to *Money Magazine*, May 1987). Small iridescent stickers send curt messages like "Open Here" in circles and triangles and ovals, also a rectangle. A nonrubber sticker blares, "Feel Me! I'm 100% Rubber." Another says simply, "You're Creative! See Inside." A card announces: "I have attended this concert in its entirety." The logo from an old Wawa coffee cup modestly boasts, "We do it just a little bit better!"

A tiny newspaper clipping, source unknown, tells us:

> Admiral Mason, who was an intelligence officer in the Far East for the Navy during World War II, said the three Gorgons were Stheno, Medusa and Euryale. He named the three Harpies: Aello, Ocypete and Celaeno. Then he identified the three Graces as Aglaia, Euphrosyne and Thalia. He named the three Gray Women as Deino, Enyo and Pephredo. He then identified the Horae as Dike, Eirene and Eunomia. He won the top prize of-fered on the program by identifying the last trio of women—the Furies—as Alecto, Megaera and Tisiphone.

Well done, Admiral Mason. This, reader, might well be the only moment in your life when the three Gray Women ever cross your

path in the company of admiralty. Likewise the "Strike a Light" matchbook or a blank deposit slip from the First National Bank of Canton, Ohio, from the 1930s. I also clung to my signed Crayola box from when I was nine and my neighbor's public library card (expires January '73) and a box-seat ticket to the Buffalo Bills versus Boston Patriots game at Fenway Park in December of some lost year before the Patriots went New England loco. The ticket is torn, was torn when I found it, and I did not see the game. Strips of hideous wallpaper pulled down shortly after moving into the first house I ever owned are as ugly as ever, nicely preserved for posterity.

Less pristine is a baseball card showing the pock-marked face of Rick Matula of the Atlanta Braves. The card has been stepped on a few times, as will happen to a discarded and not very valuable baseball card, so his flecked face is also scratched and gouged. Better for him if I had *not* picked this up from the ground. He would have been swept into oblivion and would never look so marvelously ruined as here, with his 19–23 win-loss record. He will look that way as long as my scrapbook endures, which is already way longer than two seasons.

Detritus, picked up, stashed. Scraps and pieces regain some plenitude and presence in my scrapbooks, or at least avoid the landfill, by appealing to my sensibility. And what is that sensibility? There is little inherent beauty in these bits and pieces. Instead there is often an echo of an aggravating, noisy, cluttered world, a jabbering world of commercial imperative, money on the barrelhead, or bureaucratic bog-down.

The scrapbooks exhibit some sense of composition, though they were assembled over a matter of years, little by little. Nevertheless, each time I made an entry of new material, I thought in terms of joining it to what was already there. Certain items I even chose to collect specifically because I knew they would fit in with what I had. I do make choices. I don't save every anything or any everything. I probably throw out 92 percent of what the

average American throws out. I read recently that we each throw out about a ton of trash each year. I've been seriously collecting for more than twenty-five years, and my whole collection, leaving aside the books, records, and sheet music, probably weighs about two tons, including all the binders and boxes. This shows that I am "disciplined."

I AM NOT DISCIPLINED. In the name of some kind of art, a life-collage, I have let my having run wild, to the very end of what's out there "for the taking." Each impulse I have, in the name of collecting, toward making a unity seems counterbalanced by an opposite impulse to cut up and scatter. For example, I have another collection, one I have never named, which for a number of years took the place of making scrapbooks and later gave way to the kitchen collection, described earlier. This nameless collection exists in the form of a card catalog: three-by-five cards in random order, each bearing some clipped item, or sometimes two or three, all snug within a metal drawer. I created these cards over six or seven years in the late 1980s and early 1990s, over the course of many evenings, a few at a time, working very rapidly and intuitively. There came to be eight hundred to nine hundred of the cards, and they form a serial collage, viewable in any sequence, snapshots of my wish-to-claim, meant to be taken in at a glance.

Some of the items on the cards are elemental, like the color bar found on packaging, usually on some concealed flap (its purpose is to tell the printer how well the color is printing); the admonitory words "Not for Passover use" from a matzo carton; the red rose from a Red Rose tea bag tag. Some are bits of pictures, like the teardrop of vanilla that used to be on the bottle of Schilling vanilla extract, a photo of a man sneezing, a slice of an ad showing a bottle of Passport Scotch with the Parthenon in the background, a line drawing of a man riding a steel girder suspended from a crane, a close-up of a hand in a green rubber glove with the words "EXTRA LONG CUFFS keep arms." Some are small

passages clipped from discarded books, like "a beautiful night-time experience" or "Davies had unlocked the door to foreign art and thrown the key away." Some of the cards are directly self-referential, like one bearing the words "DETACHED LABEL" or "would be in a book." Many read like the titles of Ashbery poems: "3333Rifle Barrels in the White," "Fragmentation Felt," "Pick-pock," or "To Every Sufferer Cold in the Bones." Some operate in themselves as small collages, such as a tiny obscure picture of a woman's head upside down over the words "the bane of stain" or an image of a smiling man in long johns opposite the words "What's hiding behind the pencil pleating in the dining room?" Those are exceptional, though. The montage effects come from the accidental sequences of one card following another, and those cannot be predicted in the shuffle. The order is random, and each time someone views a batch of cards, they are likely to be returned to the box in a new sequence. The collection decomposes and recomposes, and I do too, as you will have noticed.

ALMOST EXACTLY at the moment I began writing this book, I also began a new collection, complementary and antithetical to the book, but itself a book. I had an old laboratory notebook: octavo, four hundred pages, and for years it awaited contents. But all at once I knew that I wanted to fill the book with the diminutive illustrations you find in dictionaries, those skimpy anonymous imagettes, so obsequiously not Art. They aim only to convey one byte or two of verbiage from our world. Crafted as they are, and even stylish in their rejection of style, they refuse to draw attention to themselves, and never are they signed. Letters or numbers dot their surfaces to mark their nameable features as spelled out in the literature of caption (omitted). They are handy excrescences on the edifice of modern language association.

I began gluing those snippets of sign into the blank book, eventually covering more than two hundred pages. Each page holds about thirty-five images, so the number of pictures in the

book is in the neighborhood of seven thousand. To select and cut each image, to glue and position it, might take about three minutes. Thus, this book entailed approximately 350 hours of work. True, the work was relaxing to me, done in two- or three-hour evening stints, often to the accompaniment of fine music or a video, but still I spent nearly 6 percent of my life over those nine months executing this collection. By any accounting, I squandered this time, because there is no way, I believe, that this book could ever prove worthwhile by economic standards. At what

was then minimum wage, $6.75 per hour, the book cost about $2,400 to produce, but here in Santa Barbara we aspire to what is called a "living wage," then calculated as $11 per hour, which brings the cost of the book close to $4,000. That does not count the cost of the Elmer's Glue or the notebook or the dictionaries themselves, which admittedly were cheap. I used seventeen dictionaries to fill the book, and I'm sure I did not pay more than a dollar or two for any one of them. Many I got for free. Still, the cost must be entered, along with the time to accumulate them all. I freely spent the money and the hours, and all I have to show for it is this odd book.

Well, that is not entirely true. Now I have this other book too, the one you are reading. I frequently reflected on this book while busy at work on the other, and the other was my release from writing. Thus, they are companion volumes. I put a lot of work into the dictionary book, and the result is a volume stuffed with the things of the world—plants, animals, tools and machines, costumes, architectural features, body parts, geometrical forms, musical instruments, ships, snowflakes, flags, cloud formations, weapons, and more—to the point where it bulges with its plenty. It gives no picture of "purpose" or "gut feeling," which deserve to be imagined, or of "imagination." This collection is another instance of the "full boxes" impulse: containment of vital energy in a form that expresses its dumb drive.

The book you are reading is an effort to replace the inarticulate stuff of the collections with words, but the book I have lately finished is a collection that is almost a joke on taking the words out of language, reducing dictionaries to their earnest little pictures. The book I am laboring to write tries to peel back each collected thing to find the word underneath—the word and its conscious meaning, or at least its definition; it is my wordedness (world). The book I have finished, with remarkably little awareness of physical effort, seems content with its unconsciousness; it is (my) wordlessness world.

Each page holds at least two carefully selected words, positioned on either side of some tiny image. The words were column headings or catchwords from *Nuttall's Standard Dictionary of the English Language,* and I chose them because they were horizon words, beyond my ken. Put together as a pair, these obscure words generate a new level of linguistic twilight, and as a pair they form a title to each clustered page and its splash of random imagery:

MAUSOLEAN DISBURGEON

MUGGARD ITIS

TRALATITIOUS SOUTER

UNIMPORTUNED TENTACULA

PANDECT SLADE

COMPRESBYTERIAL SCULLER

MANGABY BUTT

GALACTOPOIETIC FUSTILUG

SCAPOLITE BEVILWAYS

BICONJUGATE FOLIOT

etc.

These titles stand for the superior vocabulary needed to name the full strangeness of our world. This *Practical Concocted Standard Lexikon of the Strange New World Dictionary* speaks of my interest in having the world, as one might "have" French. Like most dictionaries, it is a little overstuffed, portly, like me in a month when I do not swim enough, and yet it is also empty. No dictionary has ever provided a little picture of nothing before this one, in its entirety, did. I lined an old cigar box with felt to make a perfect ark for it. I want it to be safe and comfortable and sequestered.

Among the first to whom I showed this recently completed collection was my psychotherapist, and I could hardly stand to watch as she paged through it. I have no idea what her pleasure

might have been in the book, if any (she is far too professional to say), but I felt uneasy watching her patiently study it. (Had I over- or under-looked something?) From a little distance the pages seemed all the same to me, a uniform sign of my obsession (with what?) or my hyperbolic energy (freaky?) or my art (dull?). I had created a book that lacked utility for any purpose other than defining a nearly wordless world, expressive of my inexpressive self. This was a counterbalance to the book I am writing now, which gives voice to that dumb god who created my world and, via Adam, assigned names—labels—to all its creatures. The whole point of the project had been to provide content, a world. The book had been empty. I wanted it to be full, but the effect of my want had been to make something unaccountable and overwhelming, an object expressive of my discontent. I needed a flood and the fire next time to redeem my thwarted life. I watched my therapist measure my work with her time, silently turning page after page. To flip through the book would mean disrespect, and yet I was immediately eager that she be finished "reading" it, because I want to live, and not in a cell, even if I am the keeper. I was all prepared to leave the fallen world behind and stop wasting time. Why, I wonder, do I create objects that I presume others won't want to see? Self-hatred shouts out in this, or guilt. And it's all rather beautiful.

Wherever I have lived, I have kept the collections in an inmost recess, covered in binders and boxes, densely packed on shelves, hidden in cupboards or closets. When company comes, particular collections might occasionally make an appearance, like a shy cat that unexpectedly strides through a crowded room. However, I am the one who brings them out, and I invariably do so with apologies or embarrassment. Sometimes I feel like the man who discreetly opens his overcoat to show a rack of stolen watches or French postcards. Truly worth a look!

Of course, sometimes I think the dictionary collection is worthier than I (it exhibits hard work, precision, care, and a de-

light in those little details; it demonstrates the skills necessary to become department chair, if only I had committed them to that purpose), so . . . yes, I'm jealous of it. And, after all, I know the work to be subterfuge, a trading of diversion for credit, repression for metaphor. I know that I, as midlife critic, hesitant person, often feel more like the ruined lexicons that remain. Those gutted dictionaries show that they have lost vitally important parts, words and images, as if they had undergone some kind of stroke. They can't "say" because "INSTIMULATION" and "TENTACULA" have been removed from their vocabulary. The pile of tattered volumes is a monument to the collector's lost time and effort. This monument, like most, was created at considerable cost to the community, and yet the symbol will endure, so there should be a growing acceptance and appreciation, from me anyway, because I am growing to like myself.

THE LESSON of the collections is that collecting is not all pathology. Indeed, collecting can come very close to what is involved in the making of art. The assemblage of disparate elements into a totality evokes the satisfying metaphors of wholeness and unity, and the containment or display of what is valuable involves the very same questions of form and function that any artist must ask. Pleasure, beauty, power, truth—all are concepts applicable to the appreciation of collections. A collection is inevitably expressive of its collector, and my collections, in part and as a whole, express the ironic attitude I now take toward nothingness. I know I've got something here, an entity, in these collections of nothing, though the entity cannot stand alone. Pathos adheres. I have to be there with it for it to be something other than an enigma. My impulse to write about the collections responds to that need for me to be present, like a father, but also to my need to let them go, like a father. I have to let nothing, as art or as an idea of art, become yours.

Every last person who has read earlier versions of this book in manuscript—or even just heard its title—has begun by saying my collections are far from nothing. Why am I so insistent on nothingness when I clearly have things, and things they insist *are* important in some way? "Aren't they?" In a sense, the book guarantees that I have something, since otherwise what would the book be about? Okay, the book is about something and about someone, and even I can see that there is enough there, in the book and on my shelves, to generate a gravity. Still, I fear there is that essential emptiness inside it all, a basic absence which I obsessively try to fill.

Down near the bottom is nothing, is art. Once in a while, or in some ways subtly always, by collecting nothing, I make it, big and high and holy.

{ VI }

NOTHING AT ALL

Anecdote heard long ago: A student of English poetry, also a bi-
cyclist, devotes himself to Milton. On a journey through Europe
he brings along a copy of *Paradise Lost,* precious ounces to carry
through each pumping mile. At night he reads the epic of all
time and, having absorbed some portion, he tears out that page
or two and cycles on, each night reading more, and removing
more pages, until the book has vanished. He travels light, while
taking on dark weight.

I pick up the pages, still darker.

COLLECTING GOES ON AND ON, with a rhythmic cadence.
Unlike collecting, this book will have an end, though in some
ways perhaps the end of my collecting is this book, which ends.
I will try to make this the last chapter, but even as I write about it,
and maybe because I write about it, the nature of my collecting
changes, and so too its end.

The collecting comes from an unconscious aspect of myself,

so it's all predicate. The subject and object are self and memory. When I am in the sentence, engaged in collecting, the voice is active. When I step back, reflecting on collecting, as I have had to do here, the sentence becomes passive, and I am told that such sentences are weak. "Avoid the passive voice," say Strunk and White in *The Elements of Style*. Our writing will be livelier and more dramatic if we keep it active. Of course, the fact that I collect suggests some avoidance of drama, if not of life itself, but in the dull unconsciousness of the practice of collecting I feel alive. I'm acting on my needs. I *collect* labels. Passion is there. This book about the practice, on the other hand, parses me passive because it fixes on the subject and the object. Labels *are collected* by me. The book says: here is the collection, here is the collector. What's missing is the reader, which leads me to turn away from the ponderous things and from the vanishing self to you. Hesitantly, the book wants to know where it is going, and I need to find you to know—you, a reader so kind as to collect me.

Feeling vaguely guilty, I have started my sentence, and I will serve it until it comes to completion. Having put in thirty years' hard labor, chained to collecting, I should now be free, but in fact it feels like I must first complete this one final Herculean task (the Augean stables detail). Out of these words, all snipped from a dictionary, "I" need to make some sense, for you, among whom I include myself, my family, and the world of others whom you represent as you read about the world I have mimicked with my world of nothing. You, being someone, help me to be. You look me up down here in the dungeon.

This is a heavy task, getting worse. Unabridged labels have piled up over the years I have been writing this. I have an in-box rapidly filling with business cards, "Place Stamp Here" squares, envelope linings, and other little things I seemed to need to be the person who would want to have. Parse that. Then, please, diagram it! Once in a while, I tend to the flux of labels and such, but not with the same unthinking industry. I have not ceased the

routine of culling material from the trash, training my shopping to the stream of new labels and stickers and stubs, but when I started writing this book, I turned my attention to the collection's entire existence, and I have resolved to work out its grammar to an end. Therefore, this chapter will end the book, and this chapter will end.

HE GROANS, heavy with dependent clause.

ABOUT EIGHT YEARS AGO, I entered into the phase of my life when this book would need to be written. A midlife crisis, marked by a growing sense of despair in spite of the achievements and rewards of my career, marriage, and family, which ought to have given me hope and satisfaction, led me to psychotherapy. Psychotherapy led me to the last line of that Rilke poem, "You must change your life." I soon found myself on the precipice, or over. In midair, falling, I was in my element: nothingness—that heavy, fatty kind of nothingness, like three hundred cheese labels, not including cream cheese.

I had lately betrayed my marriage after noticing its failure for me. I was married to my dislike for myself (nothing to do with my wife), having sex with my hand, and always on the road between Claremont and Santa Barbara, between work and parenting, between a rock and a hard-on place. One drop of romance suddenly cleared the water so that I could see myself in a better life and a warmer bed. Even so, it was perhaps not too late to crawl back and resume the position. There is a lot to be said for continuity and stability and fidelity, and I had talked that talk, but I could not walk a step further. A young woman, sixteen years my junior, doctorally inclined, had shown me the door to what might be change. A brief affair preceded a turbulent period of uproar and vacillations. My confusion and ambivalence had considerably confused and disturbed the young woman. She was very cute (also smart, funny, talented, and loving). I was "unfulfilled"

(also smart, funny, talented, and loving, just a little inappropriate, just a little married). And so on—detestably midlife. But I had never done this sort of thing before, and so my confusion became my least attractive aspect. Rather hideous.

ONE NIGHT during the ambivalent, vacillating period, this girlfriend called, and from the first we knew it was a call that might become the last. She was angry and disappointed with me because of my waffling, and I was feeling abject and desolate. There was no plan and no will to make a plan. There was only the certainty of an uncertain and difficult future, as likely as not a future that would leave us all going our separate dismal ways. Yet there was this telephone call, this connection, electrons in motion, and positive and negative poles. At some point, I remarked on the fact that there was no way to know, at that second, just how this particular conversation would end. What would be the last word spoken? Only when that last word had been spoken and the telephone line had gone dead could the end, the *telos* (Greek for end and goal, the "point," a root of the word "telephone"), be determined. How would the sentence arrive at its period?

I was having my period.

I had already over the last few weeks caused a great deal of anguish in the lives of others: my children, my wife, my parents and brothers, and this young woman. I had done so as an expression of freedom, the first in a long while, and the loudest. Above all, I wanted to be loved, and she answered that need. Having been active in this way, having asserted myself and come alive, I then retreated into passivity and observed the wreckage, and also the glimmers of joy. I observed my collection of effects as a sentence in the passive: People were hurt by Dave (or delighted). Pity and fear, laughter and release, were among the effects of that spectacle. I had been a writer of the human comedy, not to mention tragedy, and now, in this telephone call, I was the critic,

a bemused and miserable onlooker, standing back and considering what I had done. And yet I was in dialogue, for the first time in so long, as if I'd come off an island, bearded and chummy with a volleyball.

I remember that the conversation entertained some of my more cynical ruminations on myself as a primally motivated being, an exponent of drives, despite the well-educated pretense of civilized behavior and moral ends. Sure, I had university degrees, but was I not skittering up tall trees and swinging from vines? Sure, I had written some academic books, but I preferred the superman soaring in my sensual life. Nietzsche came up for discussion, his deep questioning of the stolid institutions. With residual Puritan diligence, I had tried hard to think about ends and moral consequences, till my superego ached and my conscience quaked, but guilt could not displace how my id had thrilled, how my ego had awoken to the musky scent of romance.

The conversation went on and on. There were some long silences, each raising the possibility that the last word had already been spoken, some word that would still be ringing in our ears, with its tender or furious affect, but each time another word came to keep the line alive. Certain conclusions were reached. I had hurt her. Returning as I did several times to my Ward Cleaver life, I had proven inconstant, subject to certain flaws and strengths within myself, the ego I was beginning to see as my more authentic self, not that brochure of me with its glossy photos of empty rooms. Other conclusions were reached that more concerned her and her retracings. In the course of this phone call, it felt like we had each made progress, in the way one uses that phrase after a good session of labor negotiation or wood chopping, yet Pilgrim's progress had brought us to the Slough of Despond. The way up the Holy Mountain seemed obscure and overgrown with weeds, maybe impassable by two such as us.

The telephone call (this techno-connection that rolled on and on, like collecting) seemed worthwhile, even though it had

its moments of sharp pain and weepage, but still there would have to come a moment when the line would go dead. It's a technological fundamental, just as it is an editorial fundamental that this book must at some point come to an end and an ontological fundamental that so too must one's life. Time goes on indefinitely, but it also spans intervals from beginning to end. Phone calls will end with a click, lives with a whimper or a bang, books with chapter the last. The present concern was the phone call, which had stretched on toward four hours. The question remained, what word would have been spoken the instant before that final click?

I think now about the endgame, as I ponder the goal of the collecting. Will I one day have a pile of multimedia water labels, with proximity-activated 3-D video, or a handful of e-concert tickets and e-business cards and e-miscellany, awaiting e-accession at the moment of my death? Will Santa Barbara have the square footage for me to continue this habit, or will that final bit of e-phemera, take up the last molecule of oxygen, when "human voices wake us, and we drown"?

Probably all people have a fear of ends, for obvious reasons, and some have a neurotic fear that leads to strange behavior, like an inability to drop a letter in the mail slot. In this telephone call, the young woman and I were locked in the question of how our relationship would end (or resume), and I strangely insisted on making this a question that had to be addressed, if not answered, in the present phone call. Would it be "goodbye forever," which it could very well have been, so hurt were we both, or "come over now and let me kiss you so we don't have to say anything at all, at least for a while"? Finally, I think it was the Beckettian spookiness of the conversation, with the looming Godot making the meaningless meaningful and vice versa, that led us to prefer what seemed the happy, dumb ending. The last words were hers, I believe: "I'll be there soon." We collected each other, and riverran.

It is impossible to call this a happy ending. The last words from my ex-wife, a few days later, were "Fuck you." And I had to say, "Good-bye, I love you," to my kids, the hardest good-bye I've ever spoken—that piercing, heartache scene. And three years later, the last word from the young woman was also "Good-bye." And good riddance.

Not long after hearing that famous last word I began to write this book. "Good-bye" will often write a book. Three years of therapy, three years of being in love again, and then not, left me alone for a moment with much more time on my hands than ever before in my adult life. My children, who had never in fact left my life, though the geographical distance had become greater than before, had lately begun asking me why I collected, and I realized I could supply no good answer. I think they realized I was trying to say something with the collections, possibly to the world, certainly to myself, maybe also to them. So I began this book, a week or so before the towers of the World Trade Center came to rubble, a few weeks after I heard that semicolon "Good-bye," giving way to expectation of another clause in my life, independent.

The next five years were complicated ones, for the world and for me. My job was particularly taxing, with long hours and much stress. (I was department chair for five years, which brought me to know my servile self.) It seemed to become daily less and less possible to survive in the absurdly expensive coastal paradise of Santa Barbara. I was in and out of other relationships, dating a lot, telling my story over and over, and always at some point setting loose on the uncertain seas of "I'm a collector."

Four years ago I got the message from my health benefits provider that they were going to stop underwriting my therapy sessions. Faced with yet another expense in my life, I began confronting the question Freud addressed in his essay "Analysis Terminable and Interminable." Could I bring my analytical process to its end and save further expenditure of thin resources? In a

way, the writing of this book was my (thick) homemade version of the store-bought therapy I had been receiving in the office of my nattily dressed and always very professional (thin) therapist. She is a first edition, a fine example, an outstanding specimen for the legitimate collector. It took me some years to find out she was a collector herself, of something (not for me to know what), something undoubtedly fine, toward which my fees would, in some measure, go, as her work would go toward my collecting. The fact is, however, I'm not clearly able to afford her on my own terms, without the entitlement program that is or was my health benefit, which up to then had extended to my mental health.

Suddenly I was expensive.

My collections have been cheap to acquire and maintain. Though not without cost, they have fit my own psychic budget and made me feel "rich," much as my ten-dollar copayment entitled me to a therapist with an eye for *plein air* landscapes and classy socks. She keeps up with the *New Yorker*, foreign cinema, and the finer fiction. She's better than I deserve, though I hesitate to ask what that means. I really don't know what kind of a therapist I could pick out of the trash, which is where I would tend to look first. Yet, when it became clear I would have to begin paying for my sessions myself—and I have done so—I started thinking about how to bring this therapeutic thing to some end.

The writer's block I had felt for some months about this book, which was partly an effect of my overwork and emotional stress, magically began to vanish. After four plus years of psychotherapy (now eight), might I graduate and go out on my own, master of myself? Of course, I still had my thesis to conclude, and this, the last chapter, gropes for that conclusion—and you. I've been writing and rewriting this last chapter—well, the whole book actually—these last three-four-five years. I'm hoping for high honors, advanced placement in the universe, a proper commencement.

The book will come to an end, and I want that ending to express an eager belief in transcendence and freedom, but I will

live on after the last word has been written, and I will collect on, and I know that my task will be not to redeem myself but rather to own my own stuff, which includes my impulse to own. The book can be a work of art, even though it is an analysis, but I cannot be a work of art, nor can I be an analyst. I am here in the last chapter to bring this story to a close, to give it wholeness by making of this stuff a work of would-be art to be analyzed, or a work of would-be analysis to be art.

HOW TO END IT ALL? I don't like the sound of that.

Recently, in the spirit of self-acceptance and marking an end, I took off my mask. Until I was about twenty-one, I felt that I looked too young, even as I felt that I needed to seem older. So as a college senior I grew a beard. At the time, a beard could be read in many ways: poetic, countercultural, nature-oriented, or academic. Over the next two decades, as styles changed, it seemed to me that the connotations of the beard narrowed, until only "academic" remained, on the conservative side. Not coincidentally, I, who could embrace the poetic, countercultural, nature-oriented associations, gradually lost touch with them and became an academic. Wearing a beard helped identify me as faculty, not student, sage, not naïf. As I ascended along this scale I felt less and less authentic. I persisted in feeling childish, submissive, and timid in the presence of others, even those who were younger. (It was only when I had children that I came to realize that submissiveness and timidity are not necessarily childlike characteristics at all.) I discounted my own knowledge, deflected my insights, and muffled my voice.

Of course, though internally supine, mostly I was functional, and in most people's eyes I exactly fit the beard. However, the beard did not fit me. So I graduated from it at the department awards ceremony, at which we give away prizes to graduating seniors. I began the ceremony wearing my beard, but then, halfway through, unannounced, I ducked into a dressing room back-

stage and in five minutes raked it from my face. This was a setup for a skit I had arranged to conclude the ceremony. I was going to portray one of our bright-eyed, fresh-faced, eager-beaver seniors in a role he had recently acted, Hollywood executive Bobby Gould from David Mamet's *Speed the Plow*. I was going to play on the laughable disparity between the power of a Hollywood producer to "greenlight" projects and the relative impotence of a department chair, who more or less just signs forms. The main thing defeating the illusion was the beard, so I removed it and surprised everyone when the curtain rose on my clean-shaven smile. There was confusion, unrecognition, then gasps, shock, laughter, but I just carried it out to the end, feeling elated. My mask, my moss, gone.

Now I look in the mirror, and I don't look like an academic. That feels good. Do I look like a collector? Collectors, as people with specialized knowledge, seem to be a variant on academic, but they are a divergent lot. Many fields of academic study, including my own, grew from connoisseurship, the cultivated awareness of those who know what *should* be had out of what *could* be had. The academy made strenuous efforts in the twentieth century to underscore the radical difference between connoisseur and scholar, with the latter often insisting on a repudiation of market tastes and even of ownership. I knew an art historian, something of a Marxist, who made it a point of pride that he owned not a single original work of art. (Artists might understandably feel less than enthusiastic about this.) The collector is typically a connoisseur, and some make it a point of pride not to own a single work of scholarship because critical discussion often has little to do with value. There are exceptions, of course, but in my experience collectors look like merchants, and male academics look like Freud. Beardless, I no longer resemble Freud, and I look more like a collector, but I am no connoisseur. I am a cancer.

Cancers, it is said, cling. They feed on the healthy cells of the

past, transforming memory into a possession, an object to be held, consuming more and more of the present, until the house becomes cluttered and unable to sustain a relationship, at which point the author begins writing a book like this. "What is your sign," women ask me on dates, and sometimes I pretend that I don't know, but my stars stick fast to me, and sooner or later they know. We were called Moonchildren when I was a kid and first found horoscopes in the newspaper, most likely because astrologers wanted to steer clear of any association with oncology. I remember it being said that overuse of antibiotics would render a child "moon-faced." Was that lunatic? In my moon-eyed youth, in the year of Yuri Gagarin, I experienced the first death within my family, death by cancer. I have no memory of my grandfather's pain. I only recall my mother's anguish at having lost the parent who mattered most, and it seemed to me that, in her ache, I too lost the parent who mattered most. Her melancholia was pronounced from then on—maybe before that too—and I suckled on that distress. Karl Marx: "From each according to her abilities; to each according to her needs." Being born under the sign of Cancer, at the height and depth of the McCarthy hearings, which my tiny mother watched on the Philco faithfully and heavily as she bore me through that hot summer, I would have to cling to the past, its mass of memories, the womb of worry, without hope of surgical excision.

See that? Examine that last paragraph, and you will see the clinging pattern, the Cancerian drive to make something of it all, to claw onto every image, with the past constantly haunting even my prose. I fix on every pun, ready association, and ripe recollection, even of nothing other than nothing. Perhaps you've noticed. Having nothing is a struggle for life, just as having something is a reminder of death. As a consequence, this book will be nearly impossible to finish without some tremendous leap into fiction, some moment when I go beyond me-the-collector and me-the-person-who-writes-about-his-collecting to

just me-the-me. The perfect sentence or paragraph or chapter must come along that fulfills this whole (and empty) accumulation and leaves me re-created as someone unto my (crabby) self. With that I can put period to it all and know my own freedom. Freedom implies nondetermination, and yet all my work has been to reveal how determined I have been, how significant and fateful and restorative has been the flailing sentence that now seeks its end.

WHAT A SHOCK it was when I turned to a book I own but had never examined, having never had a proper coffee table, a book called *The Coffee Table Book of Astrology*, to check whether I was, as I had remembered, born in the year of the sheep. The book did not tell me (a restaurant menu a few nights later confirmed the fact), but it did lead me to read the section on Cancer, and I was astonished to find that I am a textbook Cancer, or a coffee table book Cancer at least, along with Nelson and John D. Rockefeller, Rembrandt, and Mitch Miller. Of course, as a rationalist, I presume that the terms of astrological profiles are loose enough to ensnare anyone. However, the more I look at it, the more I feel convinced that the authors of this description, Isabelle Pagan and Alan Leo, knew me, even though the book was published when I was just seven:

> The past and future are as real to him as the present. His memory is retentive, and the history of his own nation, family, or class is immensely important in his eyes. He is the teacher *par excellence*, and cares little for smoothness of outline or grace or form so long as he can drive his lesson home. His style is picturesque, vivid, often dramatic; and he continues to deliver and redeliver his message, changing and adapting its form while preserving its essence, until he succeeds in arousing the attention of his audience and kindling its enthusiasm. . . .
> The striking success of this type in the field of teaching is

partly due to this tenacity of recollection, and to the vivid pictures of childhood and youth. His memory frequently carries him back to babyhood. . . .

This type is very romantic and imaginative where the affections are concerned, though often too shy or proud to betray the fact; for ridicule is torture to the Cancerian. In consequence, the story of his love affairs is frequently a tragic sequence of misunderstandings and heartaches. . . .

Primitive Cancerians are the slaves, instead of the masters, of their moods. . . . At the early stage this is often a very unhappy sign. A sense of latent power, as yet unexpressed and inexpressible, gives the undeveloped an absurd idea of their own importance and of the deference and consideration due to them from others. Moods of exalted self-sufficiency are followed by others of exaggerated shyness and humility. Fierce pride and independence alternate with helplessness and loneliness. . . .

We find a tendency to dramatic methods. . . .

Tenacity, attachment, and clinging desire for objects are very marked. . . .

The description goes on for pages, uncannily correct. Suddenly, I looked at my hands, and I saw claws. I touched my life, and I felt the shell.

Why did I buy this book for two dollars and a half? I could easily have let it pass since I have never paid much attention to astrology. Fate placed it in my hands, and I began to see why. Having the book would stop me from discarding the possibility that my life was in the cards. I would have to know that my clinging desire for objects would result in my having stuff, because of my being born in July, that at a certain point the stuff would come to seem a collection, and, finally, that at midlife I would have to make sense of it all. And I have. The deal has been, my collection for this book, my stuff for this myth of liberation, my object for my subject. I've been buying freedom from myself,

and it has not been cheap. Hours and dollars and pages and tears have been spent. For nothing?

ALMOST EVERY SPRING for the last seventeen years, I have taught a course on ancient drama. The Athenian dramatists of the fifth century BCE were taking the collected stuff of their history and myths and making of it works of art. Sophocles, in his most famous play about Oedipus, shows how that character from myth wrestles with the discovery that his destiny was to carry out a horrendous story that was told of him before he was born. Anger toward his father did not lead him to kill his father, and desire for his mother did not lead him to bear children by her. The story said he would do those things, and despite his best efforts to avoid that fate, the story proved true. And, yes, anger and desire had their place in the chain of events; such is the play's precise ambiguity. Once Sophocles leads Oedipus to this recognition, he brings his play to an end in a way that goes beyond received myth. Oedipus cannot bear to see the drama he is enacting, so he rips out his eyes and goes on, out of the city, led by his daughter. Oedipus goes on. Only the play ends. The figure around whom meaning accumulates, about whom stories are told, might outlive the story and go on, putting one swollen foot in front of the other.

Such is always the fate of the autobiographer, and thus my fate too. You write, but you live on. You collect, but you live on. Then you die, but your written testaments or your collected objects still exist, even if only in ambiguity. Do they really reflect what you've come to in the end? My anger, desire, and search for identity have figured here among my objects, and my drama has come to a recognition, *anagnorisis*, as Aristotle calls it, a knowing again or knowing of oneself, an essential of the tragic form. My life story has achieved (or will soon achieve) a form, when punctuation proves its point. It will end, and then I will go on. But how? Surely my feet will be killing me—the poet's plaint.

I always end my teaching of Athenian tragedy by looking at

Pier Paolo Pasolini's film of the Oedipus story. Pasolini felt that the Oedipus myth, which is functional for both Freudian and Marxist analyses of the human condition, did not serve him, at least not in the way those analyses would assert. Pasolini's film is a work of projected autobiography, beginning with his own birth. At the end, we see the blind Oedipus, walking through the modern city by the house in which he was born and out into the countryside to a fertile place associated with his infancy. This is an image of the filmmaker who has lost the ability to see what is coming. He can only see what he has lost from the past. It is an unhappy conclusion, matching Pasolini's midlife despair.

I don't want this book to end on that note. I have my disgust at the stuff of the past, which surrounds and seems to determine me, but I want to believe some better end can be found for the story. I needed to play on the needlessness, the valuelessness, of the collection to find its value and necessity. Pasolini had a wealth of material to work with. He had the power to make a film according to his desires. In this way, he was an expression of bullish times, which since then have grown even more propitious, until just now. Early in the twenty-first century our collection of iconic objects has grown immense. The time comes for a market correction. My worthless collection (if you'll pardon the exaggeration and the pun) offers that opportunity. I am a figure of a wealthy man who has nothing, also of a poor man who has a lot. The Oedipal paradox is there. But unlike Pasolini, I am on the verge of creating my first work of art in a long while if I can only just complete the form and find an end to this collecting-nothing book. In terms of my emotional economy and my self-expression, I have been playing a bear market. Now comes the time for a trend of the other sort: sudden output, profit, art.

A collection, coming of age, goes beyond the collector. It takes on an identity of its own, like an adolescent child. Suddenly it exists on its own terms and has adult conversations with the world. The collector might even come to seem like the bygone

parent, an outmoded vehicle by which the collection gained its origin and early impulse, which can now be safely jettisoned. Out of a childhood in which my masculinity felt threatened—by my sister, my father, my rich friends at Andover, my artistic inclinations, and later my employers, even my students—I became a man who did not want to expose the source of his power. I kept it concealed, but in private I took solace and pleasure in making small things bigger, transforming trash. My riddle of the Sphinx tells me that, though I am a King, I am a thing among my things, a man among men, a person among people. We crawl, we walk, we grow lame, as in the riddle. Together we accumulate, without clear form, until the day we die. At that point, we leave the crutch behind. Then what?

What is the destiny of this collection, my crutch? What is *its* end? The thousands of Glamour Puss cat food labels that I did not collect have most likely all disintegrated in landfills or burned in incinerators or sunk to the bottom of the sea. Maybe one or two are quietly preserved in some accidental air pocket in a remote dump. It is a kind of miracle that one of them has been carefully preserved in a plastic sleeve and at this moment has been summoned to the attention of the world at large, to be King of Thebes. It's like a White House invitation, worthwhile even if you didn't vote for the present occupant. The democratic world is ruled by such humble examples as the Glamour Puss label, a nothing that got elected and therefore had to arrive at the crossroads, in all its political collectness. Where does it go from there?

THERE HAVE BEEN TIMES when I have thought my collection should go to the Smithsonian, "the nation's attic." However, I am uncertain the Smithsonian would accept such a collection, so low is its utility, so doubtful its aesthetic appeal. Mr. Smith's bottle cap might well go to Washington and find the door closed. It's not as if I have the pancake box of Martin Van Buren or the

business card of Betsy Ross. What's more, those underpaid curators must be constantly bothered by the string-ball and telephone-pole-insulator and Happy Meals-toy collectors out there who are similarly seeking an immortal end to their collecting. The Smithsonian space is not infinite. Why would they want to pump up their miscellany with my own?

Then too, I hate the thought of the collection going into someone's attic, even the nation's. The institution would have its own "need" for my collection, and I feel sure their need would be different from, if not opposed to, my own. While I would love to be a key contributor to a "Bacon Boxes of the 1980s" exhibit, it's more likely a few of my things would end up as set decoration for a "World of Ronald Reagan" show. The collection as such, coherent, tangible, and currently open to browsing, if you ask nicely, would be out of reach.

No, the collection should go to my children, if they want it and can stand it. I know already they will inherit my stuff, and in a sense they already have. They have borne my angst, weathered my storms, and absorbed my capacity for self-doubt and fretfulness. They have also seen that I am hopeful sometimes, and they have provoked this book from me to prove it. At least at the ages they are now, thirteen and seventeen, they tell me they want the collection. They say, in fact, that they'd like to continue it. At Ruthie's age, I was polishing stray pieces of metal. At Eva's, I was still stiff with terror at my raving sister. Lonely and anxious, I hid out in O'Neill, in the theater, in the white noise of nothing. They, in contrast, spin constantly in the center of whirling social circles, rarely more than a few minutes away from some gyroscopic friend. They act out the role of themselves, *tours de force*, on the stage of connected life. What will they do with so much crumbling cardboard, redolent of yesterday's anomie (or is that bacon grease?)?

I imagine that, if it survives, my collection will one day subside into general utility, as a humdrum memento of material

culture, but while it is in the hands of my children its utility will be a mystery, and one they might enjoy exploring on a dull weekend. What could they find in it? They could find traces of my time (as well as my times), my sensibility (methods of selection, modes of presentation), my tastes (hard to distinguish from traces of my disgust when something I acquired for the collection turned out to be nauseating), and my collecting self (understood as much in terms of what I do not collect as what I do). With a little searching, they could find themselves and their junction with the world, in the form of soup they'd supt, binkies they'd bit, scrunchies they'd snapped, and fruit rolls embossed onto the car seats. But why would they want to make this encounter? Having outworn the scrunchies and spit out the binkies, they have gone on, like plows, ripping up the soil and leaving their pea pods behind. Life marches on, while collectors trail behind, carrying a shovel and a sack.

At this point, I have little access to the material wake of their existence, all the mood rings and skorts they put on, the whitening toothpaste they squeeze onto their medium Oral-Bs, the taffy that tugs at their silver fillings, and the dental floss they use to string glass beads. Once in a while they bring me something cool from travels with their mother, like a box of animal crackers shaped like a New York taxicab or Riz Krispies from Paris. Mostly, though, my collecting blends in with my job as a realm with which they cannot connect. They don't need my history. My love, which they have, will do.

My parents are still alive, in their early eighties. This past summer my father felt those ominous chest pains, which led to aortic repair in good time. My mother can no longer see the books she once loved to read, due to macular degeneration, and her bones do not stand fast. Sixty and more years of attractive/ repulsive force, of a kind that would baffle any physicist, keeps them—and us—together and apart. They are still in the same house, though the ash pit out back, where I dug as a child, now

has a tall tree growing through it. All their belongings remain theirs, a loose collection of goods that express who they are, nothing precious, nothing cheap. At the moment, I have a few relics from them, such as chairs from my father's medical office and some books and pictures, but for the most part the inheritance of their possessions lies in the sad future. I don't think it is an accident that my brothers and I have so few of their things, but rather the result of a sound decision on their part that the taking on of their material extensions can only be a complicated process for us, and so it should be put off. They have been generous, but only with money, which is a great favor. My mother puts such low value on the sentimental attributes of objects that she recently decided to throw away the woolen blankets that had been on my bed as a child. Those same twin-bed blankets had been given to them as a wedding present in 1944. My father hid them in the garage for me, and I surreptitiously removed them from Ohio to California, where they again lie on my bed. He realized I would give them due ownership, if no one else would, and in this respect he could count on me. These blankets are not rare or precious, and the satin borders are in tatters, but so many hours of sleep seemed to me to deserve at least an afterthought. I might have been conceived in their proximity, probably was. Certainly my innocence was warmed. And on that appointed night, warm as a blush beneath those blankets, with Cindy screeching madly, I ate from the tree of knowledge.

The blankets are, perhaps, a troublesome example, on the lower edge of worldly wonder. They are not limited-edition Pendleton blankets, after all, or even especially soft. My mother did not cherish them, and I did, but they are hardly classics, and maybe they should have been dumped. Ownership constantly raises such conundrums, and collecting multiplies or hystericizes ownership. Over the years, my mother and my father have collected nothing, but they have carefully chosen all they own, for comfort, value, style, and personal statement. They are sat-

isfied proprietors of their lives. Among their things you would find some items inherited and some new, some merely serviceable, some decorative, and some moderately expressive. Their belongings might serve and speak for them, according to the howdy-do of stylistic trends, but not for me. Good taste is evident in their choices, but not stressed. There are "Colonial" touches here and there, walnut and pewter and hand-blown glass. The living room was not for living, but in the family room you could rest your feet on a pine coffee table made in the 1950s. ADHD Andy (*avant la lettre*) carved a smiling face into one surface of it when he was little, and now, under countless coats of furniture wax, the image looks Neolithic or "Early American." The huge braided rug in the family room was expensive, but its colors are warm, and it was a fun surface for shooting marbles. My brothers and I collected thousands of cheap cat's-eyes in a Baskin-Robbins bucket, and once in a while we'd make the whole barrel avalanche down the front stairs. However, we knew to pick them up and sweep up the glass shards from the few that broke. At night we fell asleep staring at the dull patterns of Williamsburg wallpaper. Posters or pennants were not especially welcome. Stress is a given in middle-class décor, where one wants to look proper but not pretentious, modest but not cheap.

Many people become collectors in anticipation of the moment when they will inherit their parents' "good" things (silverware, paintings, highboys), but I have lived away from home for so long, since I was thirteen, that I have come to look upon their things as other. I imagine it will be hard to adjust to having eventually some portion of their belongings, or not, but their stalwart way of living on, independently, has so far made that eventuality seem remote. Now, however, they weaken visibly. Moving out of the house they have occupied for half a century (exactly the span of my life) seems not so unthinkable anymore. Writing this book has something to do with anticipating that moment when all I will have of them will be inherited objects and memory, just as it

has to do with anticipating that moment when my children will move out of my immediate world and into adulthood and, later, when I will be only memory and objects to them.

My parents were part of "the Greatest Generation" (Tom Brokaw's fawning term for the World War II folk), the ones who dismantled public transportation and engineered the SUV, the ones who fought the cold war to the bitter end only to turn the U.S. into a police state. Our legacy, their pollution. Our freedom, their imperialism. Our pride, their racism. And so on. Obviously, I have issues with my parents' generation—and my parents—never more so than in November 2004 when Ohio gave Bush a reelection as dubious as the one four years earlier, assisted by their two votes and a certain amount of skullduggery. Over the years, we have mostly avoided these points of conflict and others more personal. I envy them their freedom to be comfortable in a blue-chip way, though I don't envy their particular comforts (infinite channels of cable TV, golf with plaid pants, Robert B. Parker on the novel), and I don't dig their conformity. However, I conform too, to a different set of standards, the liberal efflorescence, and I have my comforts, which they do not envy, much less dig. I suppose I want their power (their generation's power) to shape the world in my own image, but I do not want their world, which has fast become mine, and I expect my children will say the same of me. To inherit a large-screen television set is not among my dreams, so why should I imagine that inheriting a few thousand cereal boxes will be among the dreams of my children? There is a certain ache, a sense of nothingness, in both of these legacies, which perhaps should be simply buried. Nothing in my parents' stately house is from the trash, and nothing is for a museum. Nothing is perfect for me, and nothing is alien from me. Nothing hurts. Nothing helps. Nothing carries on, thank God, and nothin' says lovin' like nothin' from the oven. In fact, on some level, nothing suits my collection of nothing, and I mean nothing to a tee. Mowing their lawn again at fifty, as I did

when I was a boy, I realize that I know that post-Colonial nothing all too well.

MY REFUGE from the present, as from the past, is collecting. That's the way it has been and the way I let it be. I mean to signify something different, however, with this book. I want to open the collection, the collecting, the collector, and the heart of the collector—a series of boxes containing boxes, and thus always containing something, though ultimately nothing but boxes, nothing but nothing. A chain of dew—that is, an apparent chain, glistening and fine, but watery—links box to box. My separate moments of love for the collected things line up, as do my separate moments of being needed: by them, by my partners, by my kids, by my parents. Chains of dew. These lines suggest connection, but they do not move or pull. The instrumental chain is composed of beads of nothingness, the tugs of absence at the teats of some mythic presence, as in that signal poem of Wallace Stevens, "The Man on the Dump," which I read over and over again at just about the time I began collecting in earnest. Here he depicts the dump as the paradoxical place of infinite beauty, a place to make wonders of nothing:

> The green smacks in the eye, the dew in the green
> Smacks like fresh water in a can, like the sea
> On a cocoanut—how many men have copied dew
> For buttons, how many women have covered themselves
> With dew, dew dresses, stones and chains of dew, heads
> Of the floweriest flowers dewed with the dewiest dew.
> One grows to hate these things except on the dump.
> ...
> 　　　　　　　　　Is it peace,
> Is it a philosopher's honeymoon, one finds
> On the dump? Is it to sit among mattresses of the dead,
> Bottles, pots, shoes and grass and murmur *aptest eve:*

Is it to hear the blatter of grackles and say
Invisible priest; is it to eject, to pull
The day to pieces and cry *stanza my stone?*
Where was it one first heard of the truth? The the.

On the dump, Stevens places me, the dude with the dewiest dew,
seeking the ultimate Glamour Puss, and I find it, over and over,
in a chain reaction, in the wish to connect, bead to bead, box to
box, the to the.

DURING THE YEARS of working on this book, I have, of course,
acquired a collection of books about collecting, and I have be-
come better acquainted with the collecting world. I have seen
that collecting is not necessarily misanthropic. It can be a ve-
hicle or channel of connection. When I went, this past year, to
the Southwest/Texas Popular Culture Association's conference
in Albuquerque and met, for the first time, the members of the
Collecting Focus Group who annually meet there, I found kin-
dred spirits and an immediate recognition that my nothing was
close cousin to their something, and vice versa. I had previously
considered my collecting to be a dead end, almost by definition,
but doors were open there, doors I had ignored.

This spring, I taught a course, a freshman seminar, titled
"Collecting and Collectors," and I learned about the students'
little stashes of stones and shells, Beanie Babies and Barbies,
baseball cards, basketball shoes, and ballpoint pens. At first,
they were hesitant to speak up, as is the way of many university
students these days. With open notebooks and poised pencils,
they showed themselves willing to take in some valuable lesson
from me, but instead I gave them my grains of sand, the raw
elements of collecting, minus value, and eventually they began
to form their own pearls around them. They demonstrated that
all children collect, and a few revealed how the impulse to col-
lect could persist through the disorder of adolescence and even-

tually establish a place in adult life. Much of their collecting, though, has gone into Facebook or the iPod, all the platforms for compiling countless (digital) objects, carefully arranged in categories and containers just like any collection. The difference is, these collectors are often willing to pass on their collections to others, and they are able to do so with a single click of the mouse. I was an oddball in that room with my obstinate objects, especially when I would bring in a binder or box or album of my barely even singular nothings, but they could see the point. They could see that I am a kind of antimonk, carefully preserving and sustaining a vital darkness, heavy with various glues, through a forbidding period of enlightenment.

Just as I turned to theater, at the age of these students, for an artful way of closing the gap between me and the world, they turn to Razers, Blackberries, and Nanos, and doubtless these names will sound archaic by the time this book is published or downloaded. Meanwhile, the students will have graduated and perhaps become parents, while my office hours remain unchanged.

One day, my children and I took all the cartons of cereal boxes to the main-stage theater in my department and laid them out in a giant quilt—General Mills with Kellogg's, sugar-encrusted with organic, the cereal of my youth with the cereal of this morning. Ultimately they covered more than seventeen hundred square feet, and at the end the kids counted the whole collection. It came to 1,579 boxes (as of June 18, 2002). To deliver, assemble, photograph, repack, and return the collection took about eight hours, and much of it was hard work, but there was a joy to it also, for them as well as for me. This was the first time I had ever fully aired the cereal box collection or counted it, and it looked great, a brilliant tapestry of eye-catching graphics. A number of the people I work with, faculty and staff, stopped in to admire the array, and they all seemed to find some wonder in it, some forgotten flake or cool krispie. Ruthie had just turned thirteen,

and Eva was nine. They acted like docents, answering some of the FAQs ("How many are there?" "Where do you put them all?" "When did you start saving them?") and offering their own opinions about the most and least appetizing. So much of this cereal they had eaten, and then forgotten, oddities such as OJ's and Strawberry Shortcake, Count Chocula and G.I. Joes. We all participated in the marketing calisthenics of this panoply of late-twentieth-century morning food—the elevation of boring breakfast to an art. By way of the collection their unusual father connected to the world in a special and tasty, toasty way. From this point of view the prospect of eventually owning the collection would seem delightful, a welcome inheritance.

The possibility remains that they will come to see this collection, as I saw the stamp collection that was given to me when I was a boy, as something they did not want but had to have, a burden and a trial. We all acquire things from our forebears, both material and immaterial. Some we can use, some we cannot. Some things we must shed, others we must own as our own. I hope the kids will find something, not nothing, in what I leave to them. I hope they will find joy somewhere in all this stuff, or in this book, which repackages that stuff, or in moving beyond it all into their own collections and recollections, which I dearly wish I could acquire. Collecting has helped me to know the larger pattern in which my life is held. In the words of Keats (sort of):

The voice I hear this passing night was heard
In ancient days by emperor and clown:
Perhaps the self-same song that found a path
Through the sad heart of Ruth (and Eva), when, sick for home,
She stood in tears amid the alien Corn Flakes.

When we repacked the cereal box collection we changed its organization. Now there is an entire carton of Life, another

152

of Kellogg's Raisin Bran, two of Wheaties, two of Corn Flakes. The collection had become known, and to know is to order. We dreamed up other ways of organizing it: chronologically (using the expiration date) or from most to least healthy, according to morsel shape or grain, or according to the box's principal color along the rainbow's spectrum. Loops could talk with other loops, and pops with other pops. The cereal boxes might, with some work, coalesce into a Total work of Post-Toastie-modernist art, Sugar Smacking Hunny B Special K Cheerio seriality, with pink hearts, yellow moons, green clovers, and purple diamonds. Out of the chaos of a garage in Claremont, my children watched something that was nothing achieve order and become known, a man who could sing of it all: "Corn, we're glad you were born."

If only we can connect . . .

. . . for example, to my obsolete collection of chain letters. Try this. These are anonymous letters I received in the mail or was given, letters that directed me to connect to them and to connect myself with others. They are all earnest appeals for me to relay their message to others by mail, and yet I never sent a one. I broke the chains, thus defying the pleading and sometimes threatening commands within the letters, because I wanted/needed to keep them, which is why this chapter goes on.

Most of these letters are of the "with love all things are possible" variety, also known as the "death/lottery," and all were received between the late 1970s and 2000. Since then, the practice of sending chain letters has died away, seemingly overtaken by electronic communications, which is why I haven't added to this collection for several years and why I forgot about it until now. This is not a scam or some form of phishing, like the so-called 419 Nigerian Advance Fee Fraud scam letters, each of which tells the story of some dire situation in Africa, some dispossessed personage who requires my assistance to rescue a large sum of money from corrupt government authorities. (I also have a

collection of those, 141 at last count.) Instead, the chain letters ask nothing except cooperation in sending them on, and they promise nothing but extraordinarily good luck.

Variants of this letter begin:

"Magic"

"Kiss someone you love when you get this letter and make magic."

"Love the Lord with all good faith and He will acknowledge and He will light the way."

"Trust in the Lord with all good faith . . ."

Many, many people must have received this letter, probably millions, and maybe you. The letter usually says it has been around the world nine times, but it has been saying that since the 1970s. It must be nine thousand times by now, or nine million. Each time it came to me, which is twenty-three times, I read it, enjoyed finding the little variations, and then put it in a plastic sleeve in a notebook. I never obeyed its instructions:

With Love All Things Are Possible

This paper has been sent to you for good luck. The original is in New England. It has been sent around the world nine times. The luck has been sent to you. You will receive good luck within fours days of receiving this letter, provided in turn you send it on. This is no joke. You will receive good luck in the mail. Send no money, as faith has no price. Do not keep this letter. It must leave your hands within 96 hours. An RAF officer received $170,000. Joe Elliot received $10,000 and lost it because he broke the chain. While in the Philippines, George Welch lost his wife 51 days after receiving the letter. He failed to circulate the letter. However, before her death he received $7,755,000. Please send twenty copies and see what happens in four days. The chain comes from Venezuela and was written by Saul Anthony Degrou, a missionary from South America. Since this copy

must tour the world, you must make twenty copies and send them to friends and associates. After a few days you will get a surprise. This is true even if you are not superstitious. Do note the following: Constantine Dias received the chain in 1955. He asked his secretary to send them. A few days later he won the lottery of two million dollars. Carlo Daddit, an office employee, received the letter and forgot it had to leave his hands within 96 hours. He lost his job. Later after finding the letter again he mailed twenty copies. A few days later he got a better job. Dilan Fairchild received the letter and not believing, threw the letter away. Nine days later he died. In 1967 the letter was received by a young woman in California. It was faded and barely legible. She promised herself she would retype the letter and send it on, but she put it aside to do later. She was plagued with various problems including expensive car repairs. The letter did not leave her hands within 96 hours. She finally typed the letter as promised and got a new car.

Remember, send no money, do not ignore this. It works.

It does work, I guess. The world has repeatedly contacted me with an expression of its love and faith, and within ninety-six hours I have taken those expressions and put them into a notebook. I have not suffered to the degree of George Welch, Dilan Fairchild, or the young woman in California (How old is she now? Is she my elderly neighbor?), and yet, even though I am not superstitious, it is true. I have ignored the magic of connection, preferring instead to hoard the tokens. At last I have retyped the letter, made copies, and sent it out to you.

Today, I obeyed a modern impulse and Googled Carlo Daddit, the office employee who lost his job and then got a better one. Other versions of the letter transform his name to Carlo Dadditt, Carl Daddit, Carlo Daddis, Carlo Dadit, Carlos Daddit, Carlo Condoit, Carole Ruditt, Carl Dedis, Carlos Sanudite, Carlo De Witt, Andy Dadditt, and Andy Dodd. Nevertheless, the most

common spelling among my examples was Carlo Daddit, and I thought it was distinctive enough to turn up some hits. What better job had he gotten?

I didn't find the answer to that question. What I discovered instead was that there are a lot of *collectors* of chain letters out there, who also have this letter written by Saul Anthony Degrou (or Saul Anthony Degroup, Saul Anthony de Group, Saul Anthony De Croup, Saul Anthony De Croff, Saul Anthony De Capif, Saul DelCardio, Saint Anthony De Group, or Samuel Adams Pierce). I found an impressive Web site called "Chain Letter Evolution" (http://www.silcom.com/~barnowl/chain-letter/evolution.html), written by Daniel Van Arsdale, which contains a history of the form and an analysis of its patterns of dispersal and repetition. It turns out Mr. Van Arsdale lives in Lompoc, which is right next door to Santa Barbara. In response to my e-mail he tells me that *Scientific American* is on the verge of publishing an article called "Linking Chain Letters" (June 2003), and one of the authors is Ming Li, who teaches computer science at my own university. What link is there?

I thought of this collection, of *all* my collections, as alienated, as a repository of strange feelings, but now I can see it as a bridge I had not taken. True, I might not have all that much to offer you, fellow collector, estranged reader, and you might not have much to offer me except what you throw out, but we have at least these connections of nothing, this book, which I have written and you have read.

Please do not ignore it. It works.

{ VII }

THE REST

And on the seventh day God ended his work which he had made; and he rested
on the seventh day from all his work which he had made.　　GENESIS 2:2

In other words, on the seventh day, God created nothing. Nothing.
And He looked at it, nothing, and it was good. Nothing deserves
creation and placement in the cosmos; it deserves care and or-
dering, preservation and valuation. It deserves to be collected,
just as everything else does, all the stuff created on the other six
days. But its time is the end, the day of all the rest. After cre-
ation comes rest, the moment when becoming ceases, which is
a rehearsal of death. The nature of that rest is nothing. Nothing
is the way we know and feel death while in life, and we all, in
some way, feel compelled to touch it in its various forms, some
through neurosis, some through mind-altering substances, re-
ligion, or art. Or nothing.

At the end of the fourth year of working on this book, I find
that I have ended it many times. Writing the book at all felt like

a kind of ending, and there were times when I thought about ending the collecting with the writing of the book. Finally, the book raises, and leaves open, the questions of when and how the collecting will end, what it amounts to, where it will go. Graduation at the end of this fourth year is ambiguous.

This moment of ending writing coincides with several events in my life. I have recently turned fifty, the most momentous landmark yet in my history of birthdays, but not the most welcome. Fifty pronounces such a definite ratio on the span of life. It correlates centuries with the average length of life, to the disadvantage of the latter. Fifty from a distance seemed only ominous to me. However, I am also, in a few weeks, expecting to get married again, and feeling very happy about that. I have found a writer, a lover, a beautiful and sympathetic soul. If I am something of a Peter Pan, she is truly a Wendy, and fortunately this happy day and place is no Neverland.

Wendy and my daughters staged a birthday celebration for me as a play. Ruthie played me, wearing my clothing. Eva, who was born on Shakespeare's birthday, played Shakespeare as the essence of theater and the invention of the human, the object of my aspiration and study, while Wendy played Eugene O'Neill, the dark artist who first gave me some way of handling pain. Then, they transformed, and Wendy became our sleek black cat, Edgar, who needs nothing more than the fur on his back to survive, while Eva became a pack rat, a compulsive accumulator who is always seeking "stuff." Ruthie, still playing me, sat at a table, deeply attached to both cat and rat, Shakespeare and O'Neill, a figure of perpetual ambiguity.

Wendy also had a gift for me, which was a photograph we had seen together when in Provincetown, Massachusetts, for a meeting of the Eugene O'Neill Society. O'Neill and his new wife, Agnes Boulton, had walked the street on which we found this small gallery, which we entered on a whim. The first thing that struck my eye was a photograph by Mike Disfarmer, one I had

seen before in a book, and had loved. There it was. Disfarmer was a mysterious artist, an unhappy descendant of the farming community of Heber Springs, Arkansas, so disaffected by farming that he finally changed his name to Disfarmer. He set up as a portrait photographer and took pictures of the local folk, and somehow, with little or no training in the art, managed to convey the strange presence of an artistic instrument (the camera) and an artistic sensibility (the photographer) into a world alien to art. The power of his work was not realized until after his death when it was embraced by the art establishment.

The photograph that had captured my attention, and that Wendy had surprisingly, amazingly, bought for me, shows a young man and woman, looking bewildered at the fact of their sitting for a portrait. More than bewildered, they seem to express the dull anguish of living at all in this strange world. They are clearly a couple, but what holds them together in the photograph is the strange device favored by Disfarmer, a black line of masking tape that ran down the white wall of his studio. He frequently arranged his group compositions around this line, and it functions as a dark presence. Here, it separates the man and woman, but it also holds them together, pulling them, almost magnetically, toward it and toward each other. On her blouse, over her heart, two doves fly skyward. They are the brightest things in the whole picture. Out of the dark, this image of love soars.

I unwrapped this photograph and gasped with disbelief that something so valuable and significant, something so collectible, had come to me, and moreover that its meaning, its depiction of love, however marked by darkness, would hereafter always be mine. Ours. Discollector and his fine amour.

Coincidentally, I also had a valuable gift to give, because we had also looked into a vintage jewelry shop at the very end of our stay in Provincetown. Wendy had spotted a beautiful ruby and diamond ring, made in the 1930s, and she had tried it on, but the discovery was too sudden, too last-minute, for us to go

any further. However, some weeks later I telephoned the store and bought it as an engagement ring. My heart was pounding at purchasing something so valuable, so collectible, so good. I was going to give it away, and she was going to have it, and me.

The ring had arrived in the mail just the day before we celebrated my birthday, and so we marked big time with art, theatrical and material, objects that stood for something, and fifty years of life-now-finished opened onto an indeterminate stretch of later life, roughcast in greater happiness.

"Stretch" is a difficult metaphor to enact in the Santa Barbara real estate market. At the moment of getting married, we are also looking for a house. For the past seven years, I have been renting a spacious townhouse, and I have filled its corners and lofty ceilings. Now that we are looking at a different ratio—what amount of space one might be able to afford, or just afford—I look again at what exactly is occupying all that space. Telltale evidence of hoarding—restrained, tasteful hoarding, but hoarding nonetheless—extends vertically and horizontally through my life. Newspapers, no, I do not amass piles of the *Santa Barbara Independent* or *New York Times*, so it could be worse, but I do have a stray bound volume of the *Los Angeles Mirror*, November 3–15, 1952, thirteen days in which Ike got elected and Bing Crosby's wife, Dixie, died. It is tabloid journalism, of doubtful historical interest even in the history of tabloid journalism but still somehow appealing, to me. Having it reflects nothing of me except the Grand Acquisitor's sense that it should be had.

I also have a slew of books of the sort that antiquarian book dealers sniff at, such as an 1824 edition of the poems of William Cowper, beautifully bound in tooled leather, actually from the collection of Queen Hortense, *but* the front board is detached. Queen Hortense (1783–1837), wife of Louis Bonaparte and mother of Napoleon III, was famous for saying such things as "Everyone has his share," but my share of Queen Hortense amounts to nothing, because that board is detached. My edition of Samuel

Butler's *Hudibras* is in two leather-bound volumes from 1801, and beautifully illustrated, but many of the pages are loose and it is foxed throughout. Knowledgeable book dealers toss these treasures aside without a second thought. I pick them up.

So I have too many books. While my collected objects, such as the labels from cans of bamboo shoots, get a certain amount of regular attention from me, many of my books I have never read and never will. They stand on my shelves only because I judged them too valuable to excrete, as I knew the world would do. Waste products of the book business they might be, but I would be the retentive one.

In the end, I have a lot of *it* (rhymes with "shit"), not just books, but heaps of notes and drafts and galley proofs, and soon there will be a pile of copies of this book, as its publication becomes another momentous event in my life. That luxuriant, useless *it*, for which I will soon need another Ryder truck, turns out not to fit into an ordinary life, which is what the normal house, at least the house I can afford, was built to hold. My things make me abnormal, and I'm finding it difficult to escape *it*, the talisman of my abnormality.

I have had to discover that of my many thousand books, I could lose a third without a pang, two-thirds without any deep regret. My vast "collection" gave me an inflated sense of my self, and I had to recognize that at the center of inflation lies airy nothing. This I own: nothing. The books, in the future, I will not, and the other things too. I will take a dump, but I will have this solitary, abnormal book to take their place, this short book that should be shorter. Tear out its pages, one by one, to wipe me clean.

The story of my life. Or stories. We have these things. In this light, everyone is a collector. Experience makes for story, and stories pile up in memory. The beginning of a new relationship makes this clear, because then, at first, comes the downloading of those stories—how you grew up, went to school, fell in love, got married, got divorced, got online, how you got the nerve to

ask her out on a date. Some stories you tell, some you suppress, but eventually the library seems to empty, though "rare" volumes are often found. By then, with luck, you are having new experiences, which themselves become the stuff of stories, and so it goes on. In youth, experience feels infinitely expansive—the library unlimited—but as you go on, experiences get formed into finite collections and lives get fitted into houses. A life will ultimately have only so many chambers and chapters. Death will bring a hundred more sad or silly tales, but even they end.

It goes on, this quest. Space—property—is the place to put one's ownership, and the collector knows how that is as much a question of being as of architecture. Ownership should be about owning one's own, owning one's proper name, even owning one's own wonder. The linguistic relationship between "own" and "wonder" perfectly expresses the relationship between collecting and creation. Extended, inverted, working toward an object, I take my collection to task, tapping at the essence of its creative potential. As the comedian says, more or less, "Take my self. Please."

God had the heavens and the earth to contain his creation / collection, while I must find a finite space for my humble world, which is not exactly little and perhaps not humble either.

Wendy is neat, spare in her décor, separates her laundry, sweeps regularly. She collects nothing, though she has a thing for shoes, and she holds onto what she has read and what she has written. She has her stories, told and untold. Her profile is slim, mine expansive. I'm not sure where we'll move, but we'll move, because that is the essence of life. "Stagnant pond" is a metaphor that has haunted us both. When growth, which still is movement, is so slow as growth is during stagnancy, it frightens me. When stagnancy, which is nothing, provokes growth, it thrills me and makes me want to write a book. I believe in spontaneous generation.

WENDY AND my daughters—they are what I wanted, at bottom, when I began collecting. Collecting was a way of coping with not having them, and collecting will continue to function in that way because no human being ever really *has* another. Perhaps, indeed, no human being ever really has anything, because death carries having away. So does adolescence. So does birth. So does Eden and the fall. I will probably continue to collect, out of habit and instinct and reflex and some fear of death, but you can carry away from this book a happy ending, because my collections of nothing now hold you, too, in an embrace, which is where we need to be.

ACKNOWLEDGEMENTS

Many people have read portions of this book and offered advice and encouragement. I'd like to thank: Geoff and Melinda Aronow, Nancy Arnold, Paula Becker, Beth Berlese, Mary Breitenstein, Harley and Marlene Hammerman, Jeff and Sparky Jamison, Stanley Kauffmann, Andrew King, Janet and Bill King, Peter King, Patrick Lindley, Ellen Margolis, Patty Meyer, Werner Muensterberger, Fred Nadis, Linea Polk, Carol Press, Joel Score, Tom Whitaker, and especially Maud Lavin, Kim Larsen, and Wendy Lukomski. My thanks also go to Susan Bielstein and the University of Chicago Press for believing in this book, and me. All for nothing, and nothing for all.